LEARN TO PAINT IN 100 EXPERIMENTS

WATERCOLOR

WORKSHOP

By SASHA PROOD

Abrams Noterie, New York

Dedicated to my mom and Cam—
my support system during these
years of creative experimentation.

Design & Illustration by Sasha Prood

ISBN: 978-1-4197-2924-9

Printed and bound in China
10 9 8 7

Abrams Noterie products are available at special discounts when purchased
in quantity for premiums and promotions as well as fundraising or educational
use. Special editions can also be created to specification. For details, contact
special sales@abramsbooks.com or the address below.

ABRAMS The Art of Books
195 Broadway, New York, NY 10007
abramsbooks.com

This sketchbook belongs to:

CONTENTS

FOREWORD

By Steven Heller

I am not a watercolorist. I don't play one on TV. I don't even dabble when I'm not watching TV. Nor do I teach watercolor in any form, which is why I'll say, right off the bat, for those who want to be taught the craft, this wonderful book by Sasha Prood is an excellent choice. Nonetheless, I do have more than a passing fondness—well, let's say passion—for the art and craft of watercolor. In fact, I have two wonderful examples hanging right next to me at my desk (one by master theater poster designer and illustrator James McMullan and another by the great German Dada visual satirist Georg Grosz).

For me, like for most of us when young, our art education began with watercolor in some way or another. OK, I admit that finger paint was my first dirty-hands medium and collage came second, but the metal box with the Lifesaver candy sized circles of caked color and accompanying sable brush, was my first encounter with the act of making something approximating real art. Watercolor was my license to paint.

Of course, to do it well—to skillfully paint with watercolor—is not as easy as it looks. Yet for a youngster, innocent in the ways of art making,

it can be more liberating than oils and goauche; and somehow it feels more curiously advanced than drawing with pencil, pen, crayon, and chalk. Watercolor is the entry point for real art. Although it could be an end in itself, for me, it was a means to a greater end—an evolution from simply laying down flowing color to expressing conceptual ideas.

Watercoloring, as it was called in my elementary school art class, was never taught as a discipline but rather it was an activity. In class the kids selected their day's watercolor sets or pans at random, some with missing colors, most remnants from earlier classes, perhaps years old or looked like it. Our assignments were usually to freely express ourselves, which meant paint anything from imagination or life in whatever ways our brains and brushes could take us. It wasn't until I was enrolled, at age ten or eleven, in New York's Museum of Modern Art's Saturday art program, that I learned there were right and wrong ways to paint with watercolor. And, for that matter, I found out there existed many more colors than the simple red, orange, yellow, blue, green, and black. We were shown how to mix color, use a brush properly, achieve magically artful effects, even draw figures with watercolor, with and without outlines.

Since this was the respected MoMA, between learning technique and experimenting with special watercolor papers, we visited nearby museum galleries where real watercolorists' paintings were hung as would-be watercolorists sat nearby copying their methods. I was particularly moved by the works of Paul Klee and Wassily Kandinsky, but there were so many more abstract, expressionist, realist, and pop art where, in turn, watercolor replicated photography or defined new ways of perception.

Above all, I knew I was never going to be a proficient watercolorist (or artist at all, other than a doodler and sketcher) but watching others perfect their skills and seeing paintings and illustrations that, at times, seemed miraculous to have come from those dry little cakes, was and is inspiring. Sasha's method of teaching in this book has brought back some of the feelings I once had about the fluidity, sensuality, and serendipity of working in this medium. I'm convinced that the readers who experience this book will not regret the results.

HELLO, SHALL WE GET STARTED?!

I have found a personal connection and creative expression in the medium of watercolor. For me, it has been a play of color and texture and an experiment in control and release. Watercolor paint is about embracing each stroke of the brush—it is an opportunity for continued learning. I invite you to explore the medium that I love and in this process seek out your own modern and personalized vision.

Let's delve into the basics of watercolor painting to establish a base of knowledge first. Then let's add on layers of complexity to build skills and find an individual voice. Let's work together through the following 100 experiments, one accessible step at a time.

xo
Sasha

PREPARING
TO PAINT

HOW TO USE THIS BOOK

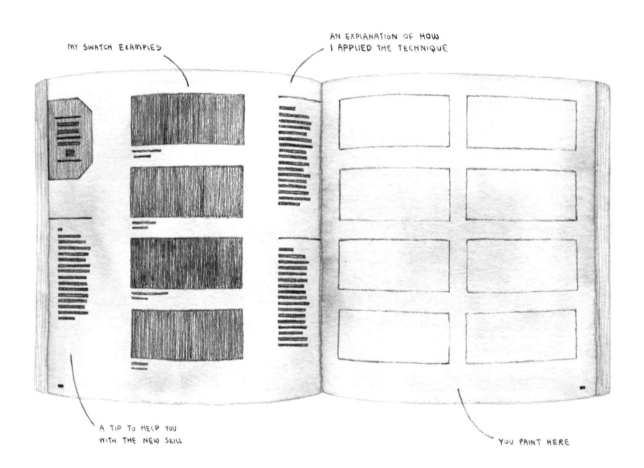

MY SWATCH EXAMPLES

AN EXPLANATION OF HOW I APPLIED THE TECHNIQUE

A TIP TO HELP YOU WITH THE NEW SKILL

YOU PAINT HERE

INTRODUCING THE TECHNIQUE

Each chapter starts with a step-by-step guide that teaches the technique we're going to explore over the next several pages.

SWATCH EXPERIMENTS

Next, we move on to swatch tests. These tests allow us to practice and develop each skill without worrying about the details of painting objects.

This is a book of 100 experiments, designed to instruct and inspire your future paintings. You will start off by exploring your palette. Next, you'll learn five fundamental painting techniques, each one building off of the next. From there, we will move on to some more specialized lifting and layering skills, and then finish off the book with some freeform painting.

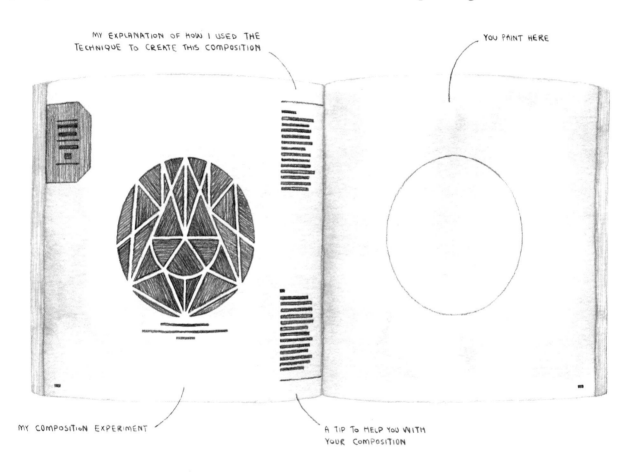

MY EXPLANATION OF HOW I USED THE TECHNIQUE TO CREATE THIS COMPOSITION

YOU PAINT HERE

MY COMPOSITION EXPERIMENT

A TIP TO HELP YOU WITH YOUR COMPOSITION

A WORK IN PROGRESS

Once we finish our swatches, we have another step-by-step guide that shows us how to use the technique in a composition.

COMPOSITION EXPERIMENTS

Finally, we move on to creating a series of paintings that apply the technique to different designs.

GATHERING YOUR MATERIALS

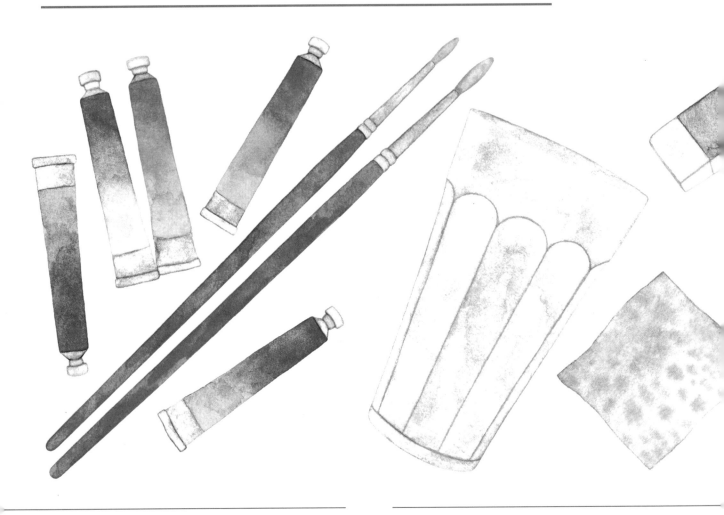

A PALETTE, PAINTS, AND BRUSHES

Select a palette (see pg. 20), paint in a range of different colors (see pg. 16), and a few varying brushes. I prefer round brushes in sizes like ³/₀, 0, and 3.

A WATER GLASS AND PAPER TOWELS

Have one or two glasses of water available. Keep paper towels on hand to use as you work.

Before we get started, you need to gather certain materials. These items can be found at your local arts and crafts stores, as well as around the home. You don't have to have professional quality supplies to experiment with watercolor—use the materials that you are comfortable with.

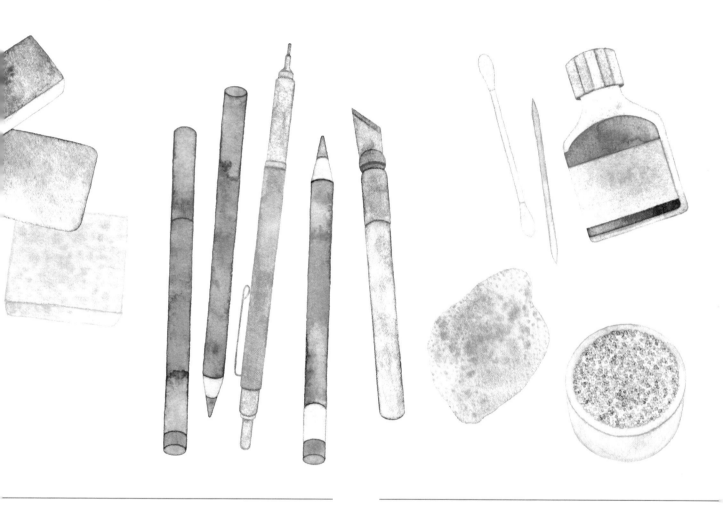

PENCILS, PENS, AND ERASERS

Get a drawing pencil (I prefer mechanical), a few colored pencils and pens, a standard and a kneaded eraser, and a rubber cement pick-up tool.

LIFTING AND LAYERING MATERIALS

Once we get to later chapters, you'll need table and sea salt, an X-Acto knife, masking fluid, tooth picks, and Q-tips, and natural and synthetic sponges.

ABOUT WATERCOLOR PAINT

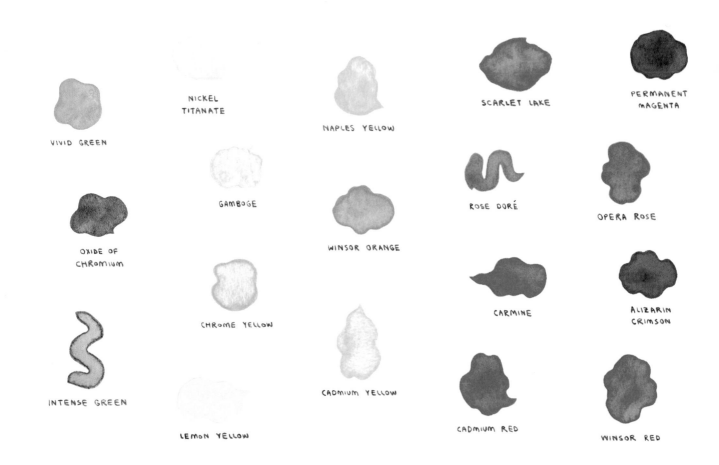

VIVID GREEN

NICKEL TITANATE

NAPLES YELLOW

SCARLET LAKE

PERMANENT MAGENTA

OXIDE OF CHROMIUM

GAMBOGE

WINSOR ORANGE

ROSE DORÉ

OPERA ROSE

INTENSE GREEN

CHROME YELLOW

CADMIUM YELLOW

CARMINE

ALIZARIN CRIMSON

LEMON YELLOW

CADMIUM RED

WINSOR RED

PROFESSIONAL VS. STUDENT

Paints come in both professional and student grade. They can vary in paintability, color intensity, and archival quality. When practicing either level will work.

TUBE PAINTS

In this book I work solely with tube based paints. With tubes, you can combine different brands, grades, and colors into a single palette.

Selecting paints can feel overwhelming. There are so many different brands and colors available, some are labeled professional and others student, and the prices vary dramatically. I suggest choosing colors that speak to you and fall within your price range. The colors below are from my personal palette and hit all prices and levels—I have been gathering them for over ten years!

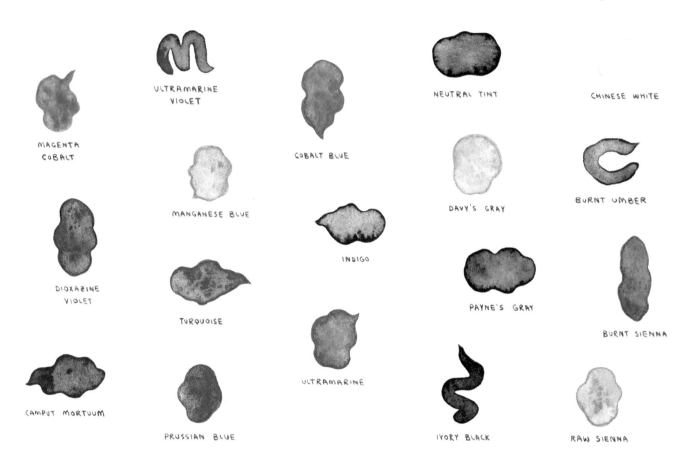

BUILDING YOUR PALETTE

You'll need a wide range of colors: greens, yellows, reds, blues, purples, etc. The exact hues are up to you. Choose the ones that excite you!

ADDING IN NEUTRALS

You'll also need to choose some browns and neutrals (black, shades of gray, etc.) plus Chinese White and Neutral Tint for color mixing.

ABOUT WATERCOLOR PAPER

THE PAPER IN THIS BOOK

This book has thick, smooth paintable paper, perfect for experiments. Like traditional watercolor paper, it may warp slightly when wet.

HOT PRESS WATERCOLOR PAPER

The pages in this book are similar to a hot pressed paper. I prefer this smoother paper because it is more conducive to painting detailed compositions.

Selecting and manipulating your watercolor paper is an important part of the painting process. Some papers are smooth, while others are more textured. Papers also come in different weights and tones. These differences are important to consider because they will effect how your final art looks. Painted paper typically warps slightly as it dries—if this bothers you, try taping down the edges of the page with artists' tape.

COLD PRESS WATERCOLOR PAPER

If you want something with the traditional watercolor texture, consider a cold pressed option. This paper will have a semi-rough feel across the surface.

ROUGH WATERCOLOR PAPER

And if you want an extremely textured page, try using rough paper. This material will have the most pronounced bumps across its surface.

PREPARING YOUR PALETTE

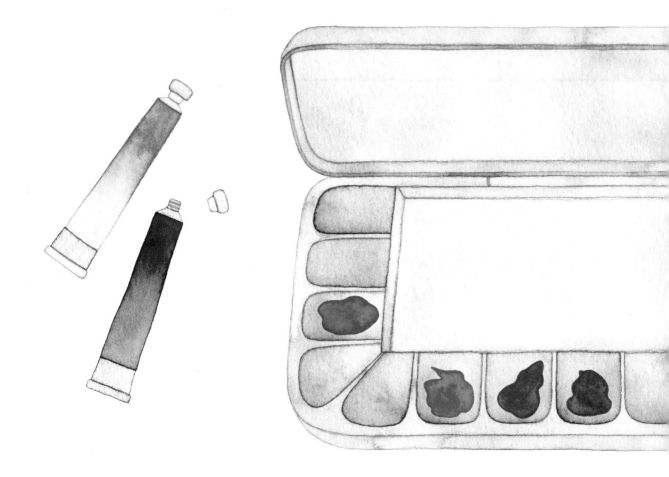

SELECTING YOUR PALETTE

All palettes have gridded space for paints and additional space for mixing. Select the palette with enough grids to hold all your paints.

ARRANGING YOUR PALETTE

Consider the arrangement of your pigments in the palette before you start placing them. I like to group similar colors together for efficiency while painting.

Now that you've gathered all your materials, you will need to do a little bit of prep work before we can get started. After you organize your paints, squeeze a small amount into each section of the palette. This will make the painting process more efficient once you get going.

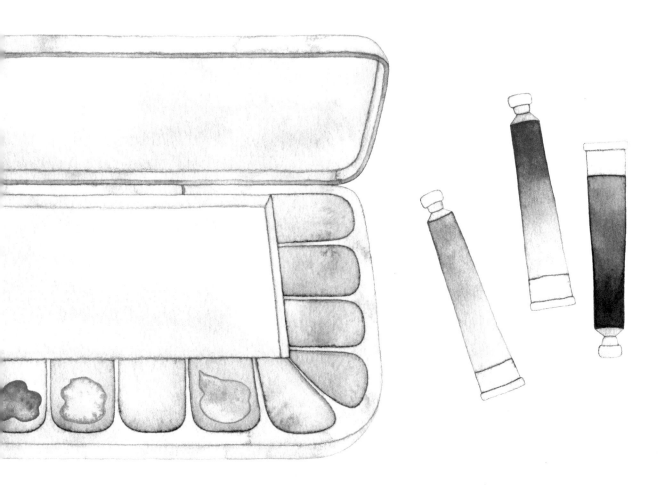

PLACING YOUR PAINT

Watercolor paint comes out of the tube as a thick liquid or paste. Squeeze only a small amount into your palette. A little goes a long way!

ALLOWING THE PIGMENTS TO DRY

It may seem counter intuitive to let a palette of paint dry, but when working with watercolors I find them easier to use once they have hardened a little bit.

TESTING YOUR PIGMENTS

Let's start applying paint to paper! To get ourselves acquainted with our pigments, we will begin with ten basic swatch tests. Pay attention to how each color reacts with water, how it feels on your brush, what it looks like on the page, and how it changes as it dries. Consider how the different hues compare to each other. Understanding how your paint behaves can help you make more informed decisions about your future projects. The pigments I use on the following tests and throughout this entire book are my everyday paint palette. I use them on everything from client projects to personal paintings to my own day-to-day experiments.

VIVID GREEN
ROUND , O

OXIDE OF CHROMIUM
ROUND , O

INTENSE GREEN
ROUND , O

TIP

Each pigment responds differently when painted. Doing swatch tests like these helps you know what to expect. Some pigments dry just as you paint them while others can change, becoming spotty. Test your pigments on the following five spreads, starting with your green pigments. Be sure to label your swatches as you paint, so you can easily reference them later. Throughout this book, my labels include the pigment name, the brush type, and the brush size.

NICKEL TITANATE
ROUND . O

GAMBOGE
ROUND , O

CHROME YELLOW
ROUND , O

LEMON YELLOW
ROUND , O

CADMIUM YELLOW
ROUND , O

TIP

I find yellow pigments to be some of the most challenging to paint with because they are very light and more opaque than the average watercolor paint. They can dry in unpredictable ways, developing unflattering spotty and muddy areas. When painting with these pigments keep a close eye on them as they dry. Smooth them with water if they start to look weird. Also, consider mixing them with other colors to make them easier to work with.

NAPLES YELLOW
ROUND, O

WINSOR ORANGE
ROUND, O

SCARLET LAKE
ROUND, O

TIP

You don't necessarily need oranges in your palette because they can be mixed by combining red and yellow pigments together, but I personally like to have some tubes around. It can be almost impossible to mix the exact same hue each time, so this helps with consistency. Once I have found a bottled color that I really like I will use it again and again. Winsor Orange, for example, is one of those must have pigments for me.

ROSE DORÉ
ROUND, O

WINSOR RED
ROUND, O

CARMINE
ROUND, O

OPERA ROSE
ROUND, O

CADMIUM RED
ROUND, O

ALIZARIN CRIMSON
ROUND, O

TIP

Some pigments appear extremely close in color such as Winsor Red, Carmine, and Cadmium Red. Pay attention to the subtle differences in hue and controllability when testing them in this section. Those little differences will be important to consider when painting future art. Before doing these tests my go-to was Winsor Red, but Cadmium Red's control lability really surprised me, changing my mind.

COBALT MAGENTA
ROUND . O

DIOXAZINE VIOLET
ROUND . O

CAPUT MORTUUM
ROUND . O

PERMANENT MAGENTA
ROUND . O

ULTRAMARINE VIOLET
ROUND . O

TIP
Different pigments have varying "paint-feels." For instance, Cobalt Magenta has a more gel-like quality, which can be challenging to paint with. A pigment like this is easiest to paint when mixed with other paints. Other pigments like Ultramarine Violet feel more fluid and handle more easily.

MANGANESE BLUE
ROUND . O

ULTRAMARINE
ROUND . O

PRUSSIAN BLUE
ROUND . O

TURQUOISE
ROUND . O

COBALT BLUE
ROUND . O

INDIGO
ROUND . O

TIP
Pay attention to how each paint flows onto the paper. Some pigments soak into watercolor paper, while others stay on the surface. In this blue example, Indigo soaks into the paper, causing dark shadows under the painting, making it harder to manipulate. In contrast, Prussian Blue sits on top of the surface making it easy to rework.

DAVY'S GRAY
ROUND, 0

PAYNE'S GRAY
ROUND, 0

IVORY BLACK
ROUND, 0

TIP
Neutral pigments are
fundamental for painting.
They can be used alone,
but are particularly
great when combined with
other colors to create
more refined mixes.

RAW SIENNA
ROUND, 0

BURNT SIENNA
ROUND, 0

BURNT UMBER
ROUND, 0

TIP
Browns are an important
part of any painter's
palette. It's helpful to
have a good mix of colors.
I particularly like these
three (Raw Sienna, Burnt
Sienna, and Burnt
Umber) because they
give me such a large
range of mixing options.

CHINESE WHITE
ROUND, 0

CW & SCARLET LAKE
ROUND, 0

CW & OXIDE OF CHROMIUM
ROUND, 0

TIP
Chinese White is meant for mixing—create a few different tints and explore how it reacts with some of your other pigments. White can be challenging to work with because it is quite opaque and can easily get spotty or muddy. Watch this pigment as it dries, and retouch any problem areas.

NEUTRAL TINT
ROUND, 0

NT & SCARLET LAKE
ROUND, 0

NT & OXIDE OF CHROMIUM
ROUND, 0

TIP
Neutral Tint is a unique pigment because it is designed to darken other colors. It is neither cool or warm, making it ideal for mixing because it will not change the original hue. Try blending Neutral Tint with several of your other paints to create multiple shades.

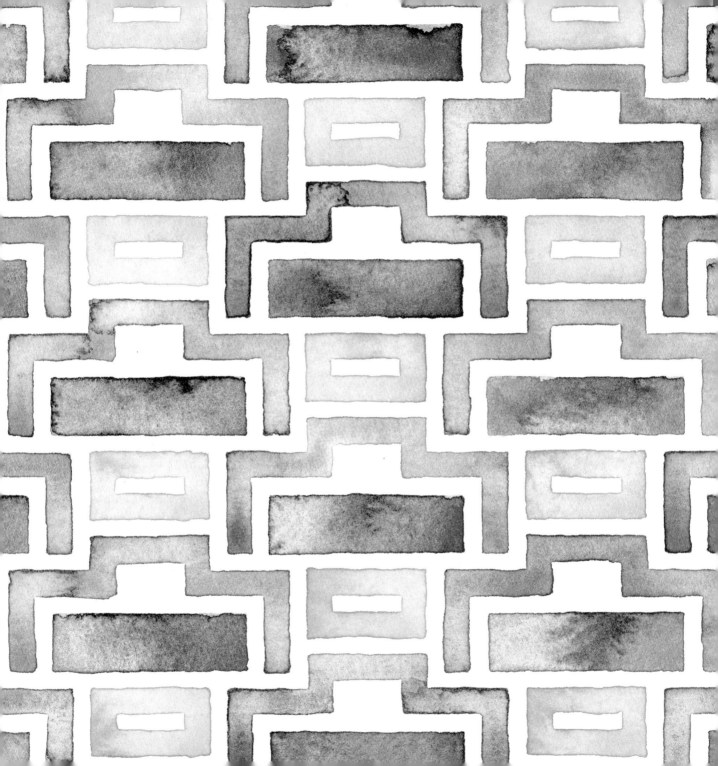

WET ON DRY

TECHNIQUE

GETTING STARTED WITH WET ON DRY PAINTING

Simply applying (wet) paint to (dry) paper

This first skill is one of the fundamental painting approaches in watercolor (and most other paint mediums). In this book, we'll use wet on dry as the starting point for many of the other techniques we'll learn. You will find that wet on dry is also the most versatile of the painting techniques. You can achieve a wide range of styles using this one basic approach. For example, applying your paint loosely with a larger brush creates visible, expressive brush strokes, while controlling a smaller brush more precisely can hide your strokes, creating more tonal shapes.

1

USING YOUR BRUSH WITH WATER

Select a brush and dip it in a glass of clean water to wet the bristles. I prefer painting with one glass and refreshing it regularly, but some prefer to use two glasses, one for dirty brushes and one for clean brushes. This allows painters to refresh their water less frequently. When your water starts looking overly cloudy it's time to get a fresh glass before it starts effecting your pigment color.

2

MIXING YOUR PIGMENT

After you set up your palette (see pg. 20), use a damp brush to pick up the pigments you want to mix. Swirl the paints together in your palette to get your desired color. Remember, a little paint goes a long way and with watercolors, you can always reuse the paints after they dry by adding a little more water.

3

GETTING YOUR PIGMENT FLOWING

Once you've mixed your color, add more water to the paint to get the pigment flowing. Be careful to balance out fluidity with color intensity. Adding too much water may lighten your color too much and an over saturated brush can cause the pigment to bleed when it touches paper. Too little water and the pigment will not flow across your page smoothly.

4

PUTTING PAINT TO PAPER

Apply your (wet) brush, loaded with pigment to your (dry) paper, and gently pull the paint across the surface to create your design. Watercolors have a way of surprising you as they dry—your art may look different when it's wet, so keep an eye on your painting throughout the whole process. You may need to go over an area again to fix an edge or smooth out a spot. Embrace the surprises— for me, they are what make watercolors so great!

OXIDE OF CHROMIUM
ROUND . 0

CADMIUM YELLOW
ROUND . 0

VIVID GREEN & CADMIUM YELLOW
ROUND . 0

NICKEL TITANATE & INTENSE GREEN
ROUND . 0

TIP

Subtle, light colors like yellows can appear to be very similar when painted. Try using these pigments with as little water as possible to get the most intense and differentiated hues that you can.

TECHNIQUE

We'll do ten experiments using this wet on dry technique, starting with some swatch tests using our green and yellow pigments. Try painting with just water and a single color first. Load your brush with paint and apply it to the paper, filling in the swatch from one end to the other.

As you paint across the shape, gradually add more water to the pigment, lightening the color as you go.

TECHNIQUE

Now let's combine green and yellow pigments into a single swatch test. Try a few experiments where you start with one color and as you paint across the shape, transition to a second color. Blend the colors together to avoid hard edges.

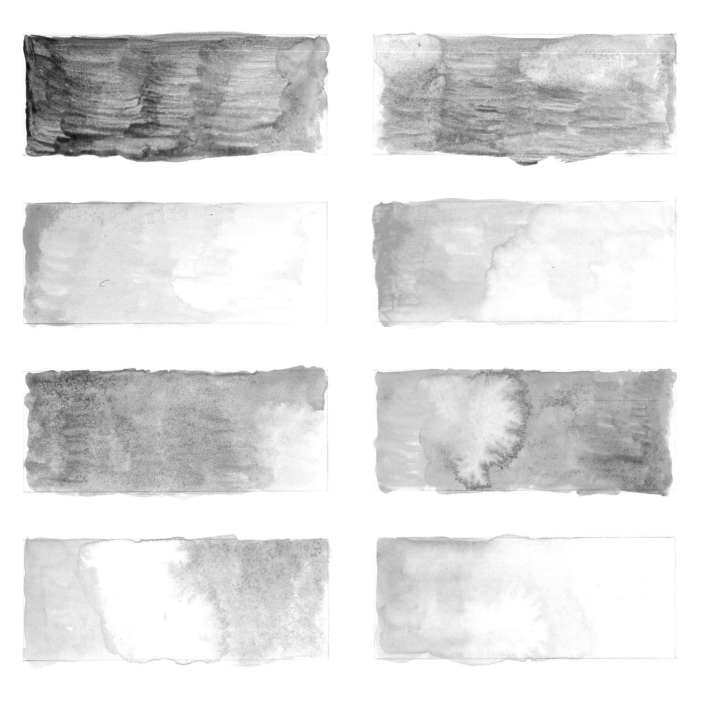

CARMINE & NAPLES YELLOW
ROUND, 0

OPERA ROSE & WINSOR ORANGE
ROUND, 0

WINSOR RED, WINSOR ORANGE & SCARLET LAKE
ROUND, 0

ROSE DORÉ, CADMIUM RED & ALIZARIN CRIMSON
ROUND, 0

TIP

When mixing multiple colors into one painting, start with the lightest color first whenever possible and move onto the darker colors after. This will help keep the colors in your painting pure and allow you to refresh your water less frequently. For example, in the first swatch test on this page, moving from Naples Yellow to Carmine allowed each color to stand out individually.

TECHNIQUE

We'll continue our wet on dry technique tests with orange and red pigments. Begin by using two colors in a single swatch. Start on one end of the shape with the first color and as you paint across the piece, transition to the second color, blending the two paints where they meet in between. Clean you brush carefully as you transition from one color to the next to keep each tone bright and clear.

TECHNIQUE

Now, let's try incorporating three colors into a single swatch. Select your first color and start painting from one corner outward. When you feel there is enough of one hue, transition to the next, continuously blending as you go to keep the paints fluid. Remember to keep cleaning your brush so you don't contaminate the next color. Switch between the pigments as you fill in the swatch to create a balanced composition, with an even distribution of each shade.

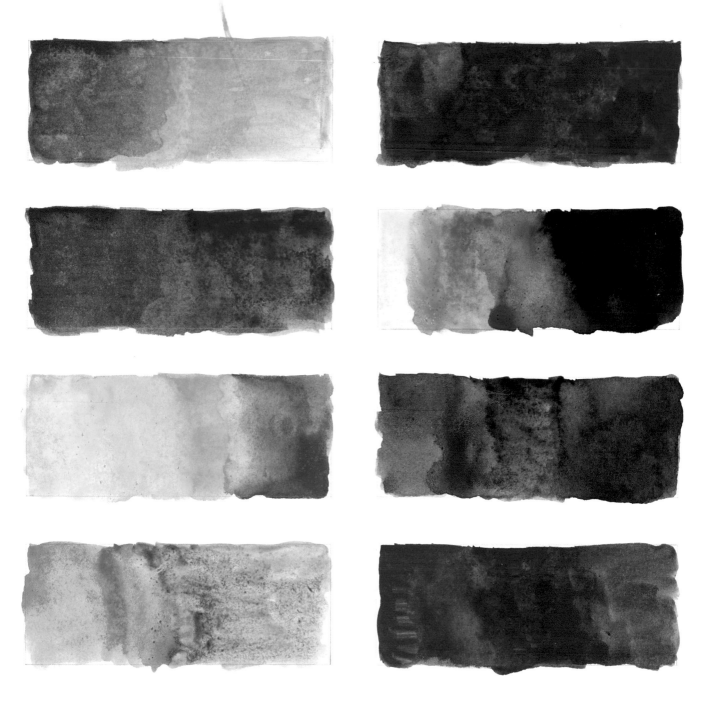

DIOXAZINE VIOLET & PRUSSIAN BLUE
ROUND, 0

ULTRAMARINE, CAPUT MORTUUM & MANGANESE BLUE
ROUND, 0

COBALT BLUE, PERMANENT MAGENTA & ULTRAMARINE VIOLET
ROUND, 0

INDIGO, COBALT BLUE & TURQUOISE
ROUND, 0

TECHNIQUE

Next, we'll practice the wet on dry technique with our purple and blue pigments. First we'll paint a few multi-color swatches where the colors flow into each other one by one. Start on one end with your first color and as you paint across the swatch, switch colors, carefully blending the areas where they connect along the way.

TECHNIQUE

Now we'll move on to several multi-color swatch paintings where the colors mix in a more organic way. Again, start by painting in one corner with your first color and rotate between the colors, being careful to blend each into the next, avoiding hard edges. Try painting some swatches using warmer colors and some using cooler colors, as I've done here.

TIP

Be sure to clean your brush frequently when painting with multiple colors in a small space. This will allow each color to pop individually. As you can see on this page, each different hue of blue or purple is still identifiable even in the more flowing swatch paintings.

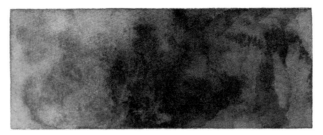

BURNT SIENNA & PAYNE'S GRAY
ROUND . O

DAVY'S GRAY & RAW SIENNA
ROUND . O

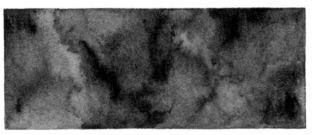

IVORY BLACK & BURNT UMBER
ROUND . O

BURNT UMBER . BURNT SIENNA & RAW SIENNA
ROUND . O

TIP

The ratio of pigment to water changes the intensity and saturation of the paint color. More water will make your color lighter or more transparent. Try gradually adding a little bit more water to your pigments as you paint and see all the values they can make. You might be surprised by how many different colors you can achieve using the black and brown pigments mixed with different amounts of water.

TECHNIQUE

Now, let's paint with wet on dry using our black and brown pigments. Again, we'll start by painting some swatches where the colors are clearly defined. Black and brown pigments come in a wide variety of shades so use these swatches to test how they contrast and blend with each other.

TECHNIQUE

Let's also create some swatch tests where the colors have a more flowing mix. Be sure to clean your brush as you paint to preserve the clarity of each color in the test. This is especially important when working with the darker pigments like Ivory Black, Payne's Grey, and Burnt Umber.

TIP

When I'm painting, I start with my brush near an object's edge but not directly on it. Even with the wet on dry technique, watercolor paints can bleed, especially if your brush is loaded with a lot of water. It's best to give yourself some room for error. I get my paint flowing first and, from there, work around the edges of an object, filling in the center as I go. Play with different approaches—try painting around the edge first or working from the center outwards and see what feels best.

CHINESE WHITE , COBALT BLUE . OXIDE OF CHROMIUM & VIVID GREEN
ROUND , 0

CHINESE WHITE , SCARLET LAKE & BURNT SIENNA
ROUND , 0

NEUTRAL TINT , RAW SIENNA & WINSOR ORANGE
ROUND , 0

NEUTRAL TINT , SCARLET LAKE , BURNT SIENNA & OXIDE OF CHROMIUM
ROUND , 0

TECHNIQUE

Now we'll paint wet on dry tests with our Chinese White and Neutral Tint pigments. For this final set of swatches, let's start by mixing white with other pigments to see how they change. Similar to yellow, white can be a challenging pigment to work with because it is also more opaque, but, when mixed with other shades, it is easier to maneuver. Create several mixes of paints with Chinese White. Use those mixes to create various styles of swatch tests.

TECHNIQUE

And finally, let's try some swatch tests where we mix Neutral Tint with our other pigments. Combine a small amount of Neutral Tint with paint in your palette. Neutral Tint is very dense so you don't need much to darken your other pigments. After you have created some mixes, apply them to your paper to create several more swatch tests.

MERGING SKILLS & IDEAS

Now that you're comfortable with the Wet on Dry technique, let's try applying it to some compositions. This is the next step to build your skill level and an opportunity to explore ideas that will inspire future works.

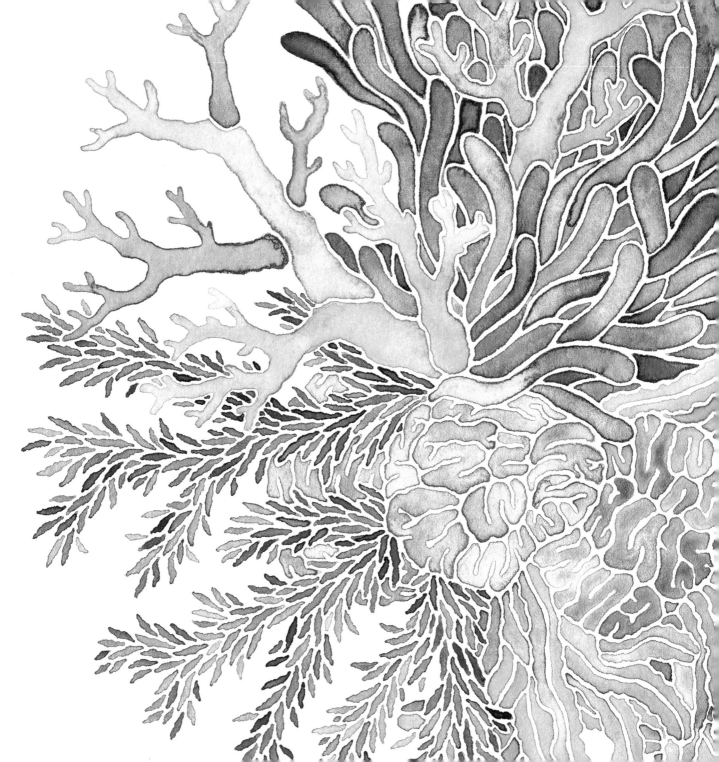

A WORK IN PROGRESS

1

SKETCHING AND GUIDES

Sketch out your design on a separate piece of paper. You can use the guidelines I've provided opposite my examples on the following pages to help transfer the details of your sketch into the book for painting.

2

PLANNING YOUR COLORS

Plan out your color palette with your design sketch. Color in the sketch to help you decide which pigments you'll use and where—that way you can focus solely on your technique while you're painting.

3

PAINTING IN ORDER

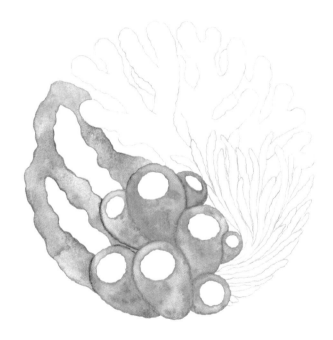

Paint from easiest to hardest—this will warm up your hand, making it easier to tackle the more complicated parts of the design. I started with the oval shaped plants because they're a simple shape.

4

FINALIZING YOUR ART

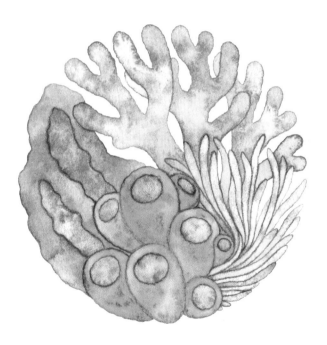

After you've finished painting, touch up any edges or spots as the paint dries. Once the art is completely dry, gently erase any visible guidelines with a kneaded eraser to finalize your piece.

TECHNIQUE

Now, we'll paint an arrangement of sea life using the wet on dry technique. As you can see, I've created a general outline for you already. You can recreate my example or fill in your own details. Plan out your color scheme and start painting the design one color at a time. When you have one design element inside another, like the oval sea plants with open centers shown here, paint the outer shape first and the inner shape second. That way you can correct any issues with the edges as you define the inner element.

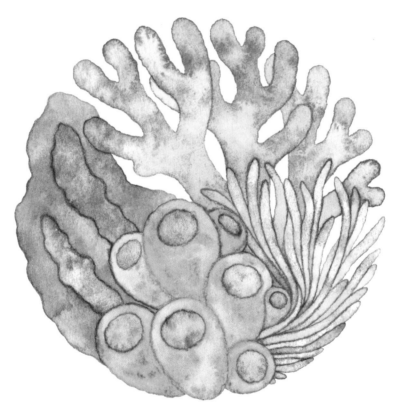

INTENSE GREEN , VIVID GREEN , MAGENTA COBALT,
DIOXAZINE VIOLET , MANGANESE BLUE , COBALT BLUE
ULTRAMARINE , BURNT SIENNA & RAW SIENNA
ROUND , 0 & 3

TIP

Paint all of one color before moving on to the next. This will help you paint faster, keep your colors more consistent, and allow your water to stay clean longer.

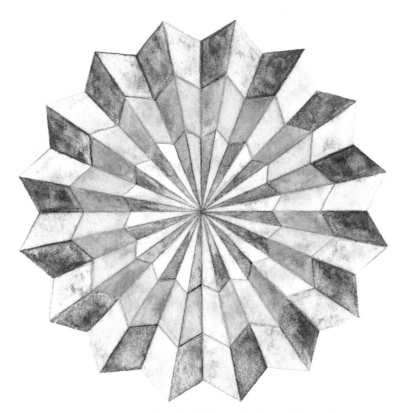

VIVID GREEN , INTENSE GREEN , MANGANESE BLUE ,
TURQUOISE , COBALT BLUE , ULTRAMARINE & NEUTRAL TINT
ROUND , 0

TECHNIQUE

Now we'll paint an arrangement of bold geometric shapes. Figure out your color scheme and paint all of one color at a time. To add a 3D effect to your design, use dark colors on one side of each star point and light colors on the other. Painting the narrow points where each of the lines meet in the center of this design may be a challenge. Using the right brush will help—make sure your brush is thin and has a nice point at the end.

TIP

Be careful when painting elements that butt up against each other, in this case the angular shapes. Wet paint can sometimes "slide" onto a painted area by accident, even if those other elements are dry. When applying paint to these areas, brush slowly and carefully, keeping the brush a little more dry than usual.

TECHNIQUE

Now, let's move on to
a delicate nature study.
To ensure that everything
will feel as though it's
on the correct layer
of the design, paint from
the background to the
foreground—in this case,
start with your leaves. Once
you've finished the leaves,
move on to the flowers,
painting from the center
of the blossoms outwards.
To define each individual
flower petal more clearly,
fill them in and then, as the
petals start to dry, drop
in a little more water to
push pigment to the edges.

ROSE DORÉ, OPERA ROSE & DAVY'S GRAY (DUSTY ROSE)
INTENSE GREEN, PRUSSIAN BLUE & DAVY'S GRAY (GREY GREEN)
ROUND, 0 & 2/0

TIP

I like to vary the shades
of my petals and leaves,
allowing some to be darker
and some to be lighter.
This adds more interest
and depth to the art than
a single flat tone would.
Play with the amount of
water you add to your paint
mixes to create this effect.

TECHNIQUE

Now we'll do some lettering using the wet on dry technique. I've painted my initials as an example, try painting your own in the space provided. Sketch out a design and paint from simplest shape to most complex shape, refining as you go. Once the design is dry, gently erase any visible guidelines to finish it off.

DAVY'S GRAY & NEUTRAL TINT

ROUND, 0

TIP

Too much graphite in a painting can change the colors, muddying the art. Once you have sketched out your guidelines, consider lightening them by dabbing the drawing with your kneaded eraser. Your guidelines will still be visible, but you will have lifted away any excess graphite that could mess with the colors in your painting.

TECHNIQUE

Next, we'll paint a more abstract lettering composition. First draw the letters and then fill in the space around them with a mix of shapes. Play with the size and proportion of the forms to add interest.

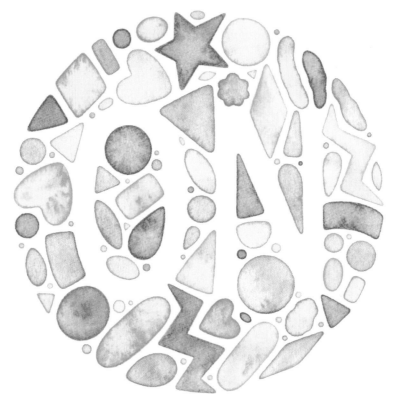

VIVID GREEN, CADMIUM YELLOW, GAMBOGE,
NAPLES YELLOW, WINSOR ORANGE & ROSE DORÉ
ROUND, 0

TIP

Using the right brush for the design can make or break your painting. My preference is for round brushes because I find you have the most control. With a round brush, you can easily paint tight corners, small details and clean edges, using just the tip. In this case, I used the tip of the brush to paint the pointy star, diamond shapes, the small circles, and the triangles. I used the side of the brush to fill in the larger shapes such as the circles, squares and hearts.

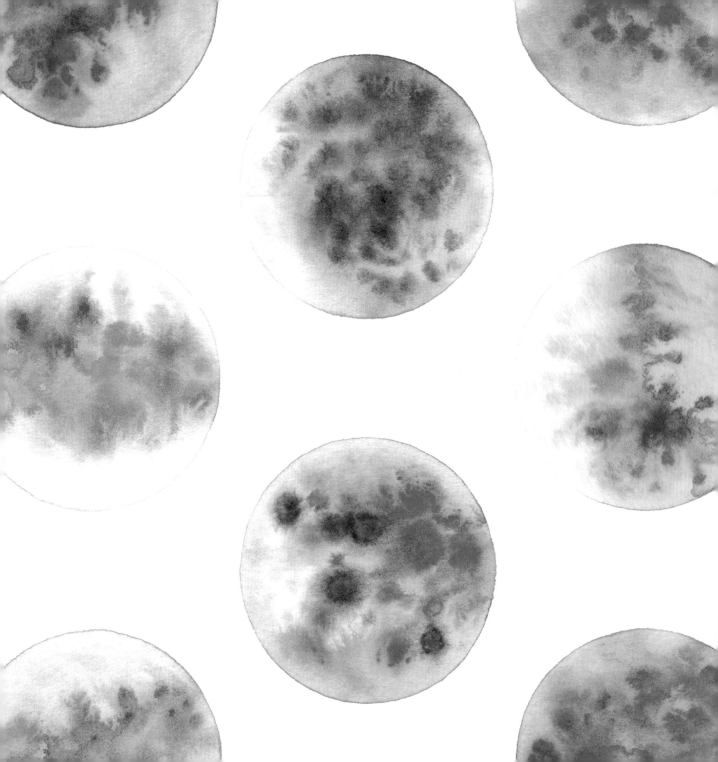

WET ON WET
TECHNIQUE

GETTING STARTED WITH WET ON WET PAINTING

Applying (wet) paint to wet paper

Now we'll move on to the wet on wet technique. This is the second fundamental painting approach that watercolor artists use in their work. This technique expands the range of effects you can achieve when applying watercolor to paper—when pigments are brushed onto wet paper they take on a life of their own. In this section we will explore how to control that fluid quality and play with when to let it go.

1

MIXING YOUR PAINTS

You will again start by mixing your paints in your palette. Add as much water as you need to get the paint flowing while maintaining the shade and tone you desire. You won't need as much water as you did for the wet on dry technique because the paper will be wet as well. Now, set these pigments aside as you prepare your paper for the paint.

2

WETTING YOUR PAPER

To prep your paper, dampen your brush and paint the page carefully with fresh, clean water. Define the edges of your design with water as precisely as possible. Lay a thin, even layer of water across the page, but not so much that it soaks completely through. The paint will flow wherever there is liquid so be mindful of where you lay down your water.

3

APPLYING PAINT TO PAPER

Now that your paper is wet and ready for paint, load a brush with pigment. Pull your brush across the dampened areas of paper to create flowing colors or use the brush tip to dot the page and create texture. How you apply your brush to the paper will change the look of your final art. Experiment with different approaches and see what aesthetic you like best. As you continue to paint, you may need to add a bit more water to the paper to keep it wet while you finish your painting.

4

REFINING YOUR ART

As you apply your pigment mixes to the paper, color will flow to the edges of the water line. Take the time to refine these edges, smoothing out any rough spots. Simply take a clean, damp brush and quickly go around the art using small strokes. Be careful not to disrupt the color too much—you don't want to overwork the pigments and make your art muddy. Let your art fully dry before you gently remove any graphite guidelines with a kneaded eraser.

INTENSE GREEN
ROUND, 0

LEMON YELLOW
ROUND, 0

OXIDE OF CHROMIUM
ROUND, 0

GAMBOGE
ROUND, 0

TECHNIQUE

We'll do ten swatch experiments using this wet on wet technique, starting with our green and yellow pigments. Try painting with just water and a single color first. Fill your swatches with clean water to start, then load your brush with pigment and apply it onto the wet paper in a linear motion to create texture. From there, go around the edges of your swatch with a clean damp brush to smooth them.

TECHNIQUE

Again, lets try painting with a single pigment and water, but this time let's create a different texture. Same as before, start by wetting your swatch with clean water. Once the area is completely damp, apply pigment to it using a dotting application. From there, clean up the edges to finalize your art.

TIP

Wet on wet can be a difficult technique to control precisely. Focus on applying color first. Leave some space around your edges so you can go back and clean them up after. To refine your edges, carefully brush them with a small, slightly damp round brush and gently move the pigment into place. A big part of this technique is embracing the organic and unpredictable nature of watercolor.

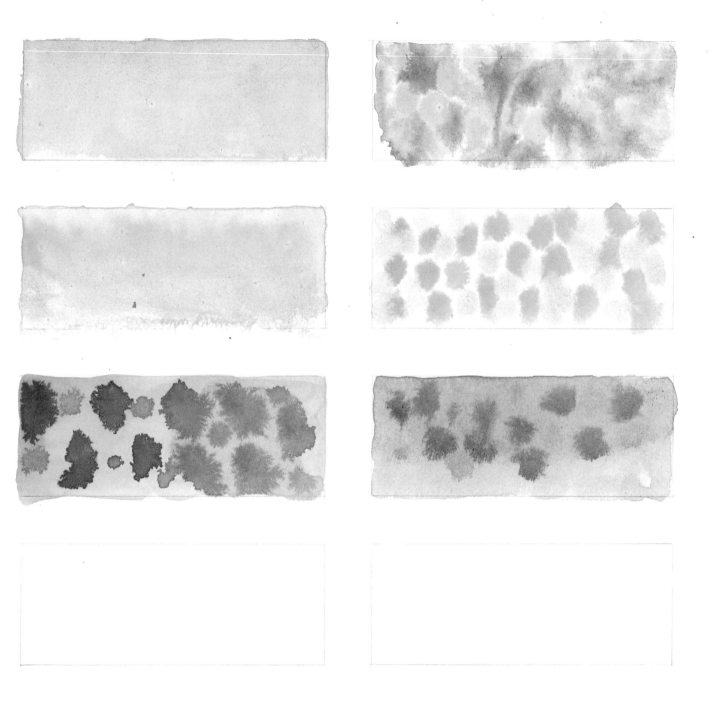

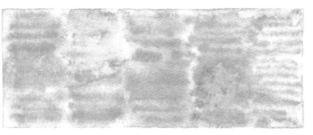

WINSOR ORANGE
ROUND . 0

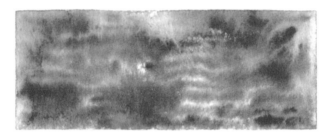

CADMIUM RED
ROUND . 0

ALIZARIN CRIMSON & OPERA ROSE
ROUND . 0

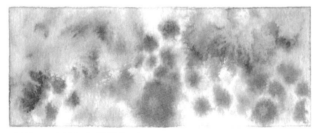

SCARLET LAKE & NAPLES YELLOW
ROUND . 0

TECHNIQUE

We'll continue our wet on wet technique tests with orange and red pigments. Keep using one color and water for a few more swatches. See how many different textures you can create with different brush movements.

TIP

When painting, I like to keep a close eye on areas that are in the process of drying. This is especially important for more unpredictable techniques like wet on wet. As the paint dries, its aesthetic can change. If you catch it drying in a way that you don't like, this is the time to go back in with a damp brush and make adjustments.

TECHNIQUE

Now, let's try incorporating two pigments into the same swatch. After you brush fresh water onto the swatch, apply your first pigment, dotting it across the space to create your design. Switch to your second pigment, being sure to clean your brush in between. Dot this second pigment onto the damp paper to fill in any remaining spaces.

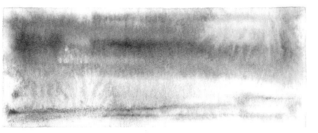

PERMANENT MAGENTA & ULTRAMARINE
ROUND . 0

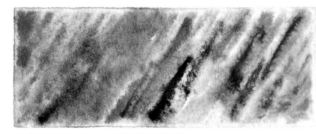

COBALT MAGENTA & CAPUT MORTUUM
ROUND . 0

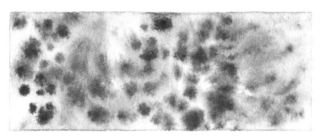

PRUSSIAN BLUE , TURQUOISE & ULTRAMARINE VIOLET
ROUND . 0

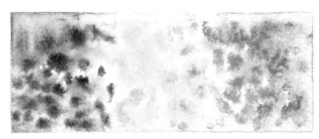

INDIGO, MANGANESE BLUE & COBALT BLUE
ROUND . 0

TIP

When painting with
a group of darker tones,
in this case purples and
blues, you can add variety
and contrast to your work
by mixing water into your
pigments to lighten up
sections of the painting.

TECHNIQUE

Next, we'll practice the
wet on wet technique
with our purple and blue
pigments. We'll start with
two pigments in a single
swatch. Use the lighter
color first, brushing it onto
the damp paper. Move on
to the second, darker
color, carefully cleaning
your brush in between.
Experiment with different
ways to place the two
colors. Try painting in two
horizontal sections or in
diagonal stripes,
like I've done here.

TECHNIQUE

Let's now try painting with
three pigments in a single
swatch. Visualize your
design before you start
painting so you don't
inadvertently mix the color
too much and get a muddy
mess. I took a light hand
when painting the two ex-
amples here, applying paint
in groupings, allowing each
color to shine individually.

RAW SIENNA , BURNT SIENNA & BURNT UMBER
ROUND . 0

TECHNIQUE

Now, let's paint using our black and brown pigments. Remember, you may need to add a little more water to the swatch to keep it damp while you finish painting. Be careful not to add too much extra water—this can cause all of your pigments to run together, losing their individuality.

PAYNE'S GRAY & BURNT SIENNA
ROUND . 0

TIP

When working with the wet on wet technique, you need to move quickly and deliberately, so as to complete your design before the water-coated surface has a chance to dry. Once the paper is dry, it becomes more difficult to add paint to your art.

DAVY'S GRAY , BURNT SIENNA & BURNT UMBER
ROUND . 0

TECHNIQUE

Try creating a dotted design using the black and brown pigments. Be sure to carefully clean your brush between colors especially when using dark pigments like Ivory Black and Burnt Umber.

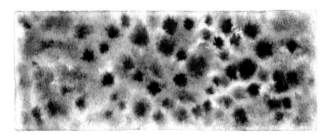

BURNT UMBER & IVORY BLACK
ROUND . 0

CHINESE WHITE , NAPLES YELLOW & VIVID GREEN
ROUND . O

TECHNIQUE

Now we'll use our wet on wet technique with our white pigments. For this set of swatches, start by mixing Chinese White with other pigments and see how they change. Now apply them to your dampened swatch using a mix of different painting approaches. Play with the subtle tones in different configurations.

CHINESE WHITE , PERMANENT MAGENTA & RAW SIENNA
ROUND . O

TIP

If you paint a color onto your paper and then decide it's too dark, dab a bit of white pigment and/or water onto the painted area to lighten it up.

NEUTRAL TINT , CADMIUM RED & PERMANENT MAGENTA
ROUND . O

TECHNIQUE

And finally, let's try some swatch tests where we mix Neutral Tint with our other pigments. Apply your paint mixes to your wet swatches using different painting approaches. Try overlapping the colors in sections like, I've done here.

NEUTRAL TINT , INTENSE GREEN & COBALT BLUE
ROUND , O

MERGING SKILLS & IDEAS

Now that you've practiced the wet on wet technique, let's move on to some compositions that use this approach. This will show you how to use what may feel like an abstract skill in functional ways and will help you discover how it can enhance your paintings.

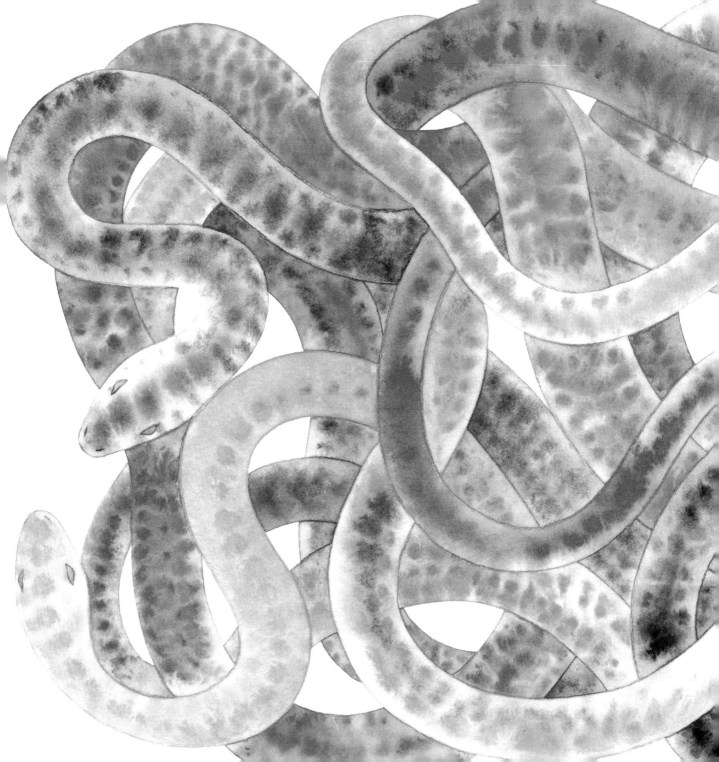

A WORK IN PROGRESS

1

SKETCHING AND GUIDES

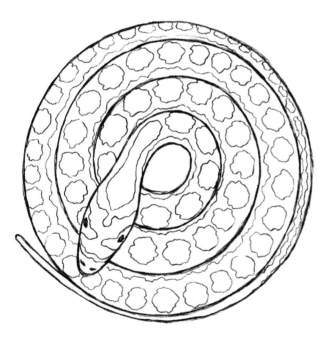

Start by planning out your design on a separate piece of paper. Once you've created a composition that you like, use the guidelines I've provided to help you transfer your sketch into this book for painting.

2

PLANNING YOUR COLOR

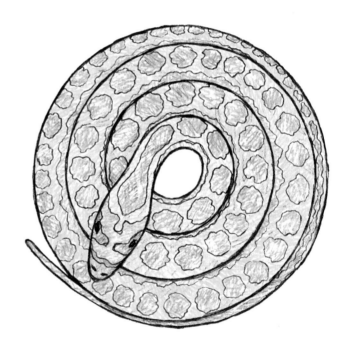

Plan out a color palette for this painting. Consider which pigments you'll use and where you'll place them by coloring in your sketch.

3

PAINTING IN ORDER

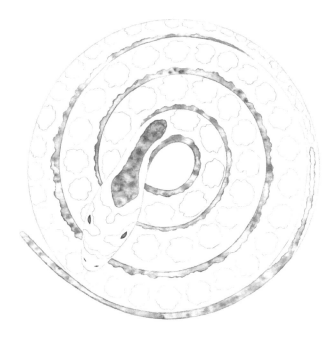

Paint from easiest to hardest to warm up your hand. I started with the large sections of decorative scales because they're simple shapes. Especially with wet on wet, be careful to let each area fully dry before moving on.

4

FINALIZING YOUR ART

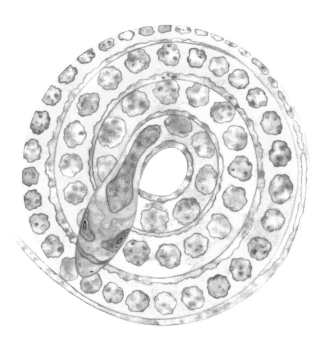

Once you've completed your painting, refine the edges and touch up any problem spots with a damp brush as the paint dries. Once the art is fully dry, gently erase any visible guidelines with a kneaded eraser to complete your art.

TECHNIQUE

Next, let's create your own snake using the wet on wet technique. Start painting the design, one color at a time. Wet each section with clean water as you go. Try to paint all of one color before moving onto the next. Use the different textures that we practiced. The dotting approach is the perfect way to create scales. Once you have filled in each section, go back and refine edges and spotty areas to complete your composition.

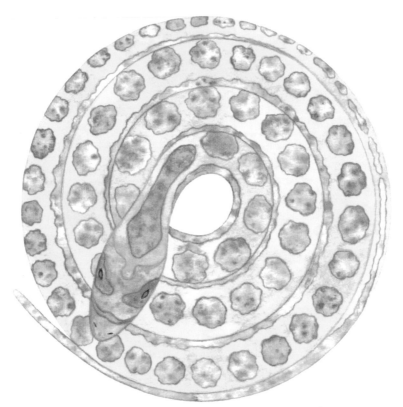

CADMIUM YELLOW, WINSOR ORANGE & SCARLET LAKE
ROUND, O & 3/0

TIP

When painting with the wet on wet technique, patience is necessary. You are using a lot of water on the paper's surface and this takes time to dry. I would suggest not painting too many areas at once— you don't want to brush your hand against a wet surface and mess up your art. Some people use a hair dryer to speed up the drying process. Be careful though, it can disrupt how the pigments are arranged on the surface, changing your design.

COBALT BLUE, IVORY BLACK, OPERA ROSE,
ULTRAMARINE VIOLET & PERMANENT MAGENTA
ROUND 0 & 3

TECHNIQUE

Let's paint a geometric design. Start by planning your palette—you have a lot of space to fill in this design, so a larger range of colors could be nice. I am working with five pigments in this case. Carefully brush water onto your design, keeping your edges clearly defined. Once the design is completely damp, start with your lightest shade and move on to progressively darker shades, dotting one pigment at a time. Consider the composition when applying each color. In this case, I did not want the colors evenly dispersed, so I chose to clump certain shades together. Once you are done applying pigments, go back in with a clean brush to refine the edges.

TIP

When painting such a large and intricate space with the wet on wet technique, it is vital that the surface be fully damp from edge to edge before you start working with pigments. Paint the full surface with water and go back around with a clean, damp brush to touch up any drying spots as often as you need to. Don't rush this process— it takes time to get it right.

TECHNIQUE

Now, let's paint some colorful berries. Plan out your art with light graphite guidelines and visualize your color palette before beginning to paint. Start with the easiest shapes first. For me, blueberries and currants are easier because they don't transition from one color to another like the others do.

INTENSE GREEN . CADMIUM RED . ALIZERIN CRIMSON ,
ROSE DORÉ , PERMANENT MAGENTA , MAGENTA COBALT .
MANGANESE BLUE , COBALT BLUE & RAW SIENNA
ROUND , 0 & 3

TIP

When your design calls for particular colors to be in specific places—in this case, the strawberries need green leaves and red fruit—be mindful of how much water you are using to dampen your surface. When you need this level of control, you want to use less water. Practice will help you find the right balance.

TECHNIQUE

Let's move on to a lettering piece made up of organic shapes. I'm focusing on a single letter for mine— in this case the letter "B." Draw subtle guidelines to define your letter. From there, plan out each of the organic shapes you'll use fill in the remaining space When you are ready to start, work from easiest t hardest carefully filling in each of the shapes.

DAVY'S GRAY, PAYNE'S GRAY,
BURNT UMBER, BURNT SIENNA & RAW SIENNA
ROUND, 0 & 3

TIP

If you want to incorporate a lot of different colors into a wet on wet design, it is best to work quickly and with a light touch. Don't overwork the art. A heavy hand in the wet o wet approach can easily turn muddy. Less is more

TECHNIQUE

Finally, let's paint some handwriting-inspired lette ing. Write out a word in the center of your circle and thicken the letters as desired. Create a pattern that fills in the space around the letters and defines the circle. Visualize your color scheme before painting. Vary your brush strokes to create different textures. I chose contrasting colors and textures to visually separate the different com ponents. Finish off your art by smoothing out any rough edges and spotty areas with a damp brush.

ULTRAMARINE, MANGANESE BLUE & INTENSE GREEN

ROUND, 0 & 3

TIP

If you want to create layers of paint on top of each other using the wet on wet technique, it is possible. To keep the layered elements from bleeding into each other. Let each layer of you design "set" for a day or so before starting the next

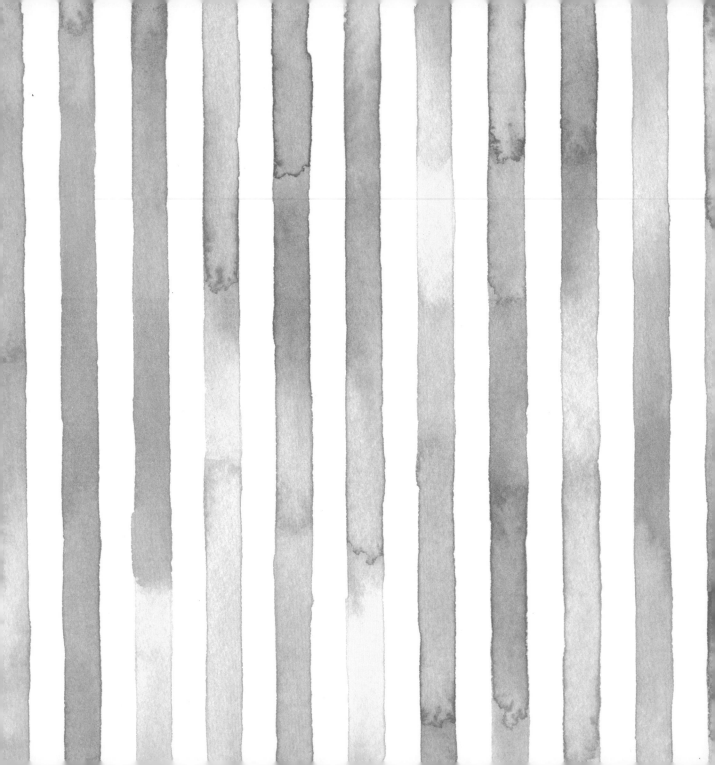

OMBRÉ

TECHNIQUE

GETTING STARTED WITH OMBRÉ PAINTING

Colors that flow into each other to create a gradient

Next, we are going to work on blending colors together within our painting, to create an ombré effect. Now that you are familiar with the two fundamental ways to apply paint to paper (wet on dry and wet on wet), you can hone these techniques and learn to control them at a more refined level by developing your color control.

1

PLANNING YOUR PALETTE

Ombré is all about color, so thinking carefully about your palette is particularly important when working with this technique. Take the time to determine the hues you want to use and where they will be placed in your design before moving forward with painting. Mix any colors you need in advance so you can keep your focus on executing the technique.

2

PUTTING PAINT TO PAPER

Now that you have planned out your color palette, it's time to start painting. Always try to work from the lightest to darkest pigment so your colors stay true in tone. Apply your first color, and when you're ready to move on to the next color, proceed to the next step.

3

BLENDING TWO PIGMENTS

When you want to start transitioning to your next color, take some of your current pigment and combine it with water in your palette. Add a small amount of your next pigment to this mix and apply it to the page, smoothly blending the colors together. Continue adjusting your mix and applying this evolving shade onto the page. Try to move quickly so the paint does not start to dry to avoid creating hard lines.

4

REFINING YOUR ART

Depending on how much space you want this color transition to fill in your painting, you will need to adjust how gradually you blend the pigments into each other. For instance, if you would like a more subtle shift in color, add the second pigment to your mix by very small amounts. To finalize your ombré art, clean up any ragged edges and smooth out any spotty areas with a clean, damp brush.

TIP
Move quickly when painting transitioning colors. You don't want the paint to dry and create hard edges that interrupt your smooth ombré.

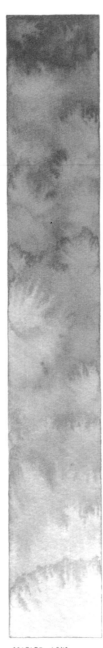

SCARLET LAKE
ROUND, 0

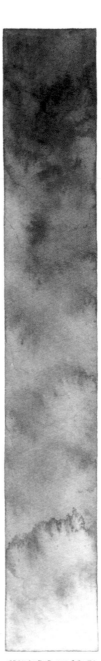

PERMANENT MAGENTA
ROUND, 0

COBALT BLUE
ROUND, 0

TECHNIQUE
We'll start using this ombré technique with some swatch tests that combine a single color with water. Start at one end of your swatch with your selected pigment. As you transition down the shape keep mixing more water into the paint to lighten the shade as you go. By the time you get to the end of the swatch, the color should be significantly lighter. Refine the edges and smooth out any spotty areas with a damp brush.

TIP
Some of the most unlikely
color combinations can
create the most beautiful
gradients. Be adventurous
with your palette in this
section of experiments—
you might be pleasantly
surprised with what
you discover!

ALIZERIN CRIMSON
& OPERA ROSE
ROUND, 0

BURNT SIENNA
& DIOXAZINE VIOLET
ROUND, 0

MANGANESE BLUE
& PAYNE'S GRAY
ROUND, 0

TECHNIQUE
Now we'll continue our
ombré technique tests
with some two-tone
experiments. Try using
a combination of warm
colors, another of cool
colors, and one that uses
colors you do not expect to
work together. Start on one
end with the first color. As
you get about a third
of the way into the swatch,
start mixing in small
amounts of your second
color. Keep painting this
transitioning color onto you
swatch, allowing the hue
to gradually shift. Try to
complete the change by
about two thirds of the way
down the swatch. Finish
painting the swatch with
your second color and
refine the art, making any
necessary touch ups.

TIP
When painting ombré,
be careful with the quantity
of water you use throughout
the painting process.
You need enough water to
keep your paints flowing,
but adding too much water
can make it difficult to
control the color shift.
In watercolor, the more
control you need, the less
water you want to use.

WINSOR ORANGE,
OPERA ROSE &
CHROME YELLOW
ROUND, 0

VIVID GREEN,
MANGANESE BLUE
& RAW SIENNA
ROUND, 0

INTENSE GREEN,
OXIDE OF CHROMIUM
& DAVY'S GRAY
ROUND, 0

TECHNIQUE
Next, we'll practice the
ombré technique with
swatch tests that combine
three pigments. Keep
experimenting with combi-
nations of warm and cool
colors, plus at least one
swatch with three colors
you aren't sure will work
together. Try using three
similar tones of color, like
I did with the green swatch.
See how much variety you
can get with your pigment.
Plan out each palette and
consider where you want
to transition from one
color to the next. Once
you have finished painting
touch up any spots to
finalize your art.

TIP
To keep your colors even all the way down your swatch, focus on painting from side to side, basically zigzagging your way down the entire shape. Overlapping your brush strokes like this will also help keep your paint flowing, to avoid any unwanted edges.

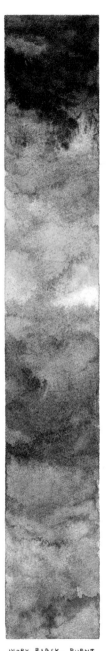

TECHNIQUE
Let's now try painting with four pigments in a single swatch. Again, paint a few warm color mixes, a few cool color mixes, and at least one wild card combination. Try alternating between lighter and darker colors like I did in these swatches.

ROSE DORÉ , COBALT
MAGENTA . PERMANENT
MAGENTA & OPERA ROSE
ROUND . O

TURQUOISE . MANGANESE
BLUE, DIOXAZINE VIOLET
& CAPUT MORTUUM
ROUND . O

IVORY BLACK . BURNT
SIENNA . PAYNE'S GRAY
& BURNT UMBER
ROUND . O

TIP

When touching up a painted element with multiple colors, it can be challenging to keep the hues in place. Clean your brush several times throughout the touch up process so that you don't start pushing colors around too much.

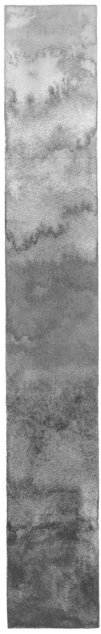

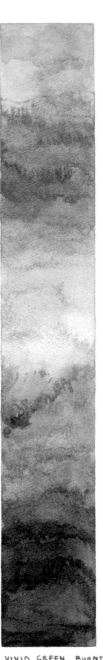

TECHNIQUE

And finally, let's try some swatch tests where we really go for it and paint five pigments in a single shape. For these last swatch tests, go free-form and pick any combination of colors that you want. When working with so many colors, it is particularly important to plan out your palette and visualize your color distribution in advance of painting. Start on one end of your shape, painting down it, mixing each color as you go. Experiment with how gradually you shift your colors. Once you've finished, touch up any rough edges and spotty areas with a clean, damp brush.

WINSOR ORANGE, ROSE DORÉ, SCARLET LAKE, MANGANESE BLUE & PRUSSIAN BLUE ROUND . 0

OPERA ROSE, CADMIUM RED, CAPUT MORTUUM PERMANENT MAGENTA, & ALIZARINE CRIMSON ROUND . 0

VIVID GREEN, BURNT UMBER, RAW SIENNA, INTENSE GREEN & IVORY BLACK ROUND . 0

MERGING SKILLS & IDEAS

Now that you have worked with the ombré technique, let's explore several practical applications for this skill in some compositions. This technique allows you to use color in a more refined way across your work, portraying everything from the delicate shifting color in flower petals to the flowing shades of water.

A WORK IN PROGRESS

1

SKETCHING AND GUIDES

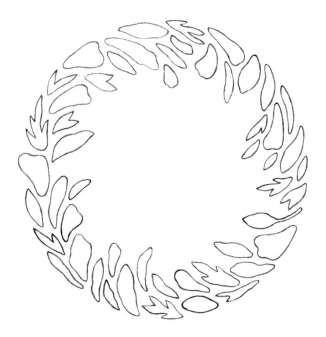

Plan out your art on a separate piece of paper. Once you've figured out the design, use the guide-lines provided to help you transfer your sketch into the book for painting.

2

PLANNING YOUR COLOR

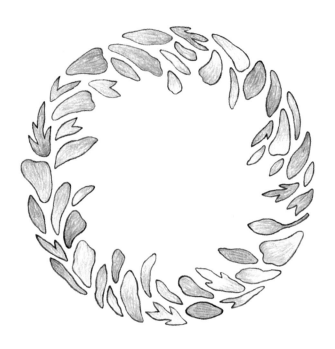

Plan out your color palette just like you did with your design sketch. Decide which pigments you'll use and where, and mix them in advance. That way you can put all your focus on executing this technique.

3

PAINTING IN ORDER

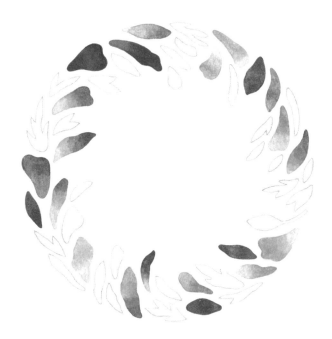

Paint from easiest to hardest to warm up your hand. I started with the larger individual petals because they're a simple, rounded shape and there's more space to fill in the ombré.

4

FINALIZING YOUR ART

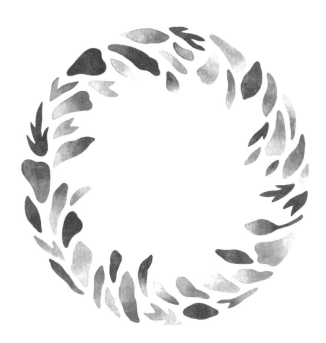

Touch up any rough edges or spotty areas as the paint dries. Once the art is completely dry, gently erase visible guidelines with a kneaded eraser to finalize your design.

TECHNIQUE

Paint your own petal art
using the ombré technique.
For this composition, you'll
use a variety of sizes for the
petals. Plan out your color
palette in advance of paint-
ing, and have your mixes
ready. Paint from one end
of each petal to the other,
starting with your first
color, transitioning through
your gradient, and ending
on your second color.
Refine each petal as they
dry to fixing any color
issues or rough edges.

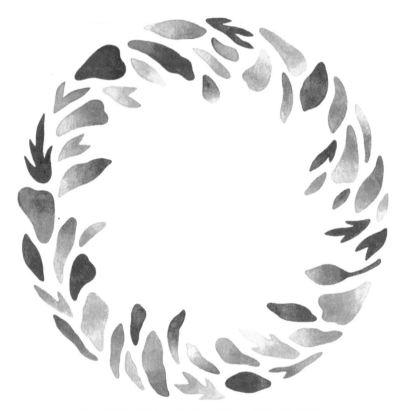

CADMIUM YELLOW, WINSOR ORANGE, SCARLET LAKE,
CADMIUM RED & ALIZARIN CRIMSON
ROUND, 0

TIP

When painting ombré
colors in smaller elements
it can be harder to control
the flow of the pigment—
try using less water then
usual to keep more control
over the paints.

TECHNIQUE

Let's now paint a geometri[c]
study. Consider your
pigments before starting
to paint. Think about how
to use color to further
refine your design like
I have done here. Each
shape within the study ha[s]
its own color combination[.]

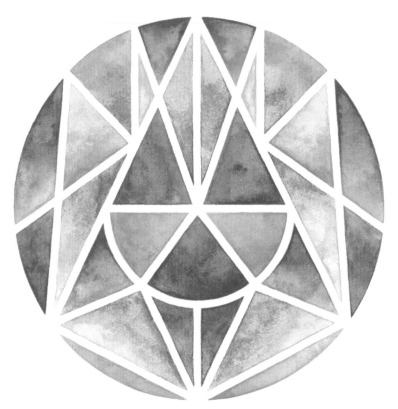

OPERA ROSE, WINSOR ORANGE,
CADMIUM YELLOW, NAPLES YELLOW & RAW SIENNA
ROUND, 3/0

TIP

If you are struggling to
execute color gradients i[n]
small spaces, try painting
one color at one end of
the shape and the second
color on the other end of
the shape and only blend
them into each other in
the center. This can help
keep your pigments even[ly]
dispersed, preventing
one color from overtaking
the other.

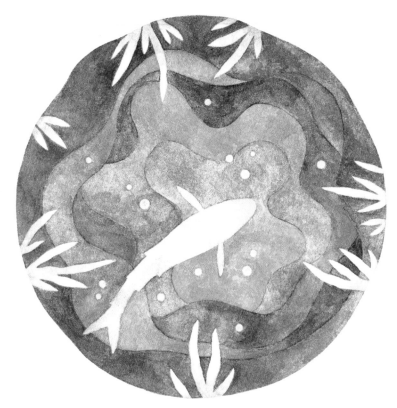

INTENSE GREEN , COBALT BLUE & ULTRAMARINE
ROUND , O

TECHNIQUE

Now, let's create a painting of a koi pond. Plan out your art with subtle guidelines and consider your color selection in advance. When possible, paint outer elements before inner elements, so that you can define every shape precisely. For example, I started with the water at the edge of the pond and worked inward. Refine each element before moving on to the next, and make any final touch-ups at the end with a damp clean brush.

TIP

If an element in your painting ends up with some uneven color distribution, touch up your painting by going back in and wetting the area with clean water first and then adding color to even out the tones.

TECHNIQUE

Let's move on to a lettering piece made up of linear shapes. I'm focusing on a single letter for mine—in this case the letter "A." Draw subtle guidelines to define your type and consider your color palette before applying any paint to paper. Work from the outer elements inward. Transition colors as you go, mixing pigments together a little at a time in your palette. Refine the edges and fix any spotty areas to complete your art.

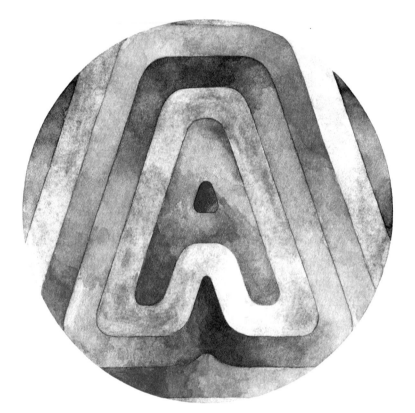

OPERA ROSE, PERMANENT MAGENTA, CAMPUT MORTUUM, MAGENTA COBALT, DIOXAZINE VIOLET, ULTRAMARINE VIOLET, MANGANESE BLUE & ULTRAMARINE

ROUND, 0 & 3

TIP

When painting an object that connects in a loop—like the letter "A" shown here—it can be hard to move quickly enough to paint all the way around the before it dries. This can leave an awkward hard edge—an effect that we are trying to avoid when painting gradients. Try working back and forth between both ends to keep the paint flowing until you can connect them in the center.

NAPLES YELLOW, CAMPUT MORTUUM, IVORY BLACK, PAYNE'S GRAY,
DAVY'S GRAY, BURNT UMBER, BURNT SIENNA & RAW SIENNA
ROUND, 0

TECHNIQUE

Finally, let's paint some camouflage inspired lettering. Sketch out a wor in the center of your circle lightly with graphite.
Fill in a design around it and consider how you want to place color on your design. Paint from one end of each strip to the other, gradually transitioning you colors as you go. Refine the art with a clean, damp brush to finish.

TIP

When painting a series of shapes that are close to each other like these lines there are lots of different visual choices that you car make with the ombré.
You not only choose your colors, but also what pro-portions to distribute them in and where to place them I chose to create a free-form design with an even distribution of colors place sporadically throughout the piece. As an alternative, I could have matched up th colors from stripe to stripe to create one large gradien across the entire painting. See what appeals to you!

BLOOM

TECHNIQUE

GETTING STARTED WITH BLOOM PAINTING

A flower-like texture created by paint disrupted by water

Now that we've practiced blending colors into each other, it's time to focus on the different textures pigments can create on the paper's surface. We'll start with one of the primary approaches called blooms. While many watercolor artists avoid them at all cost, I embrace them in my work. In this chapter we will experiment with this playful attribute of watercolor painting. Learning to control these blooms can add a dynamic movement to your work.

1

PREPARING TO PAINT

In the same way that you would approach any other painting, you will start out by planning your design with a sketch. Create light graphite guidelines to follow as you paint. This is also the time to consider your palette and how you would like to arrange these tones across your design.

2

HOW BLOOMS ARE FORMED

Blooms are created when areas of paint are pushed outward by strategically adding extra water. This additional liquid moves the pigment toward the edges of the watermark forming organic shapes that resemble flower-like blooms.

3

APPLYING PAINT TO PAPER

To execute this technique, brush your paint mix onto the surface of the paper. Allow the pigment to almost dry, and then brush with more water and/or paint, disrupting the damp surface. Add enough water to make sure you are pushing the pigments outward. This displaced paint is what will form your blooms. Depending on the amount of texture you want, you may need to repeat this step several times. For this technique, it can be helpful to use two glasses of water, one for painting your design and another just for creating your blooms

4

REFINING YOUR ART

Once you have achieved the amount of bloom texture you are looking for, refine any rough edges with a clean, damp brush. Allow the paint to fully dry, and gently erase any visible guidelines with a kneaded eraser.

CADMIUM RED
ROUND . 3

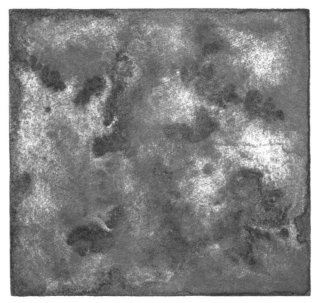

ULTRAMARINE
ROUND . 3

TIP

If you want to get more
defined blooms, paint
the swatch and let it dry
until it is just barely damp.
This is the perfect moment
to add additional water to
your form, disrupting the
pigment most effectively,
and creating the larger
blooms you are looking for.

TECHNIQUE

We'll do ten experiments
using this bloom technique
beginning with some single
color swatches. Starting
at one corner of your
swatch, paint up and down
the shape, zigzagging your
brush to keep the paint
flowing as you fill in the
entire form from one end
to the other. As you fill in
the swatch, keep an eye
on how the paint is drying.
Go back in with a clean,
wet brush and use the
water to shift around the
pigment you've laid down.
This will create the bloom
we're looking for. During
this process you will have
to multi-task, going back
and forth between filling
in the form and creating
the blooms. Once you have
completely filled in the
swatch, continue to work
on the blooms while
refining any rough edges
and spotty areas.

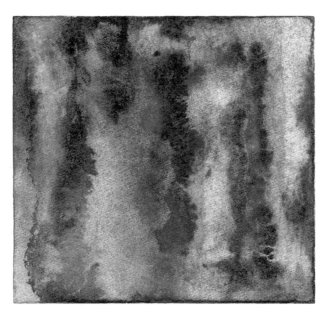

PAYNE'S GRAY & COBALT BLUE
ROUND . 3

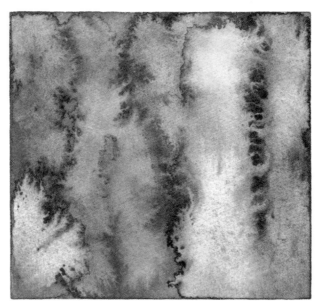

ULTRAMARINE VIOLET & BURNT UMBER
ROUND , 3

TECHNIQUE

Now we'll continue our bloom technique swatch tests with some two color experiments. Plan out your color combination in advance of starting the painting. Switch back and forth between pigments as you fill in the swatch to create an even distribution of the two hues. Once the paint is almost completely dry, brush fresh water onto the surface to push the pigments around. Pay attention to how the blooms shift the two different pigments. Touch up any problem spots to finalize your painting.

TIP

Be patient while creating blooms. If you try to rush them and add too much water too quickly you will wash away the pigment.

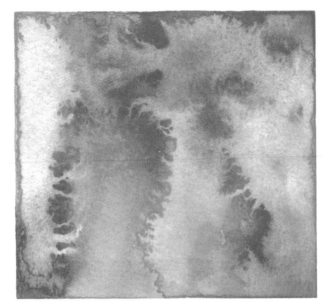

CHROME YELLOW, WINSOR ORANGE & OPERA ROSE
ROUND, 3

TECHNIQUE

Next, we'll practice the bloom technique with swatch tests that combine three pigments. Plan out your palette in advance of painting, mixing any hues you need at the start. Switch back and forth between the pigments as you go, creating a balanced distribution of colors. Try different configurations of color as I've done here. The lower swatch is painted in thirds whereas the pigments on the top swatch are more integrated. As the paints dry brush fresh water onto your form, creating the blooms.

TIP

When painting a large form, such as these bloom swatch tests, it can be hard to maneuver your hand across the entire shape. Rotating the page can help you find the perfect angles to complete your painting.

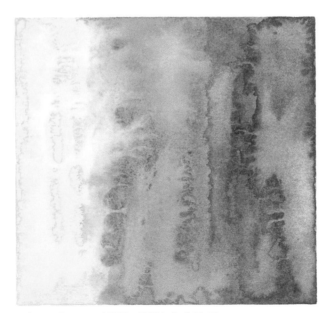

CHROME YELLOW, INTENSE GREEN & TURQUISE
ROUND, 3

TIP
You can go back into your painting several times when developing blooms. This takes patience. You have to let the surface dry almost completely each time but when you want a lot of overlapping blooms, this is an effective method.

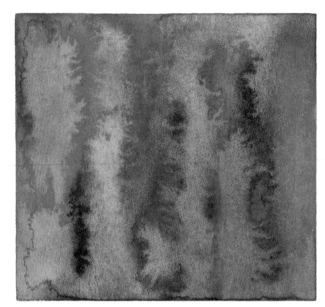

PERMANENT MAGENTA, OPERA ROSE, CAPUT MORTUUM & ULTRAMARINE
ROUND. 3

TECHNIQUE
Now let's try painting with four pigments in a single swatch. Consider your color selection and mix your pigments in advance of starting. Try using contrasting color combinations like the blue and pink or the red, orange, and blue I've used here. As the paint starts to dry brush the swatch with fresh water to develop blooms. Continue until you have filled in the entire test. Refine the blooms, any rough edges, and spotty areas to complete your work.

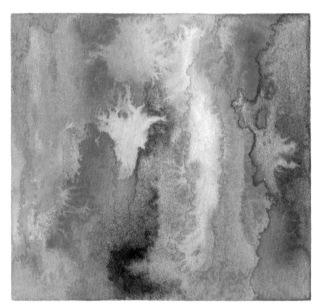

ROSE DORÉ, WINSOR ORANGE, SCARLET LAKE & MANGANESE BLUE
ROUND. 3

TIP

When combining so many colors into a single form it can be hard to keep them distinct. Be deliberate with your placement and consider filling in larger areas of space with each shade, to help them stand out more as individual tones.

CADMIUM RED, BURNT SIENNA, OPERA ROSE, RAW SIENNA
& WINSOR ORANGE ROUND . 3

BURNT UMBER, DIOXAZINE VIOLET, PAYNE'S GRAY, COBALT BLUE
& PERMANENT MAGENTA ROUND . 3

TECHNIQUE

And finally, let's try some swatch tests where we combine five different pigments in a single shape. For these last swatch tests it's even more important to plan your palette and mix your colors in advance as there are so many. Select your first color and start painting on one corner of your swatch. Brush up and down your form, switching to different shades as you go. As the paint dries, go back in and add fresh water to the pigment to create your blooms. Once you have filled in the whole swatch, refine the art by touching up any problem spots.

MERGING SKILLS & IDEAS

Now that we have had a chance to experiment with blooms, let's explore how this dynamic technique can enhance our compositional work. We'll paint a flower with delicate textural petals, a geometric study with flat clean shapes that contrast this organic movement, a wood study where blooms suggest the material's natural texture, and more!

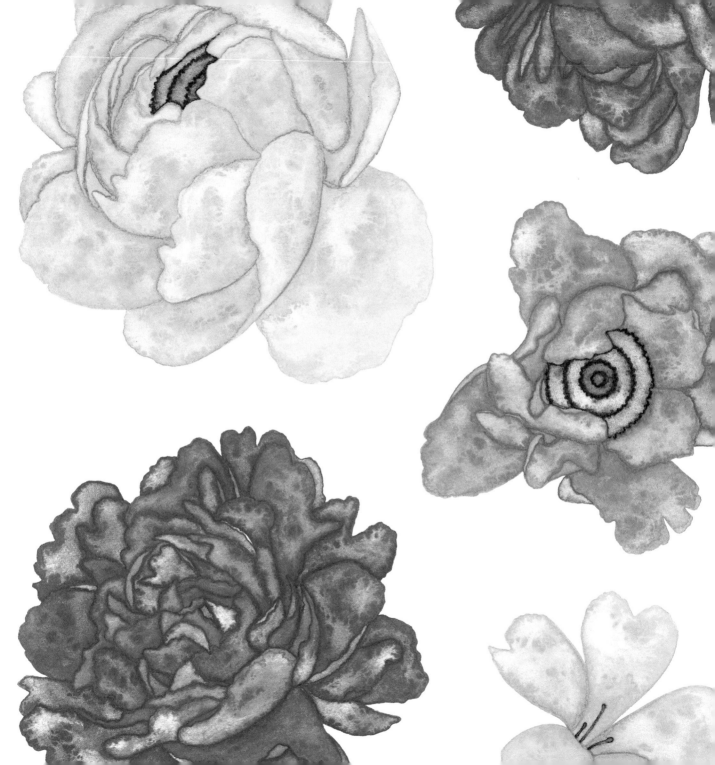

A WORK IN PROGRESS

1

SKETCHING AND GUIDES

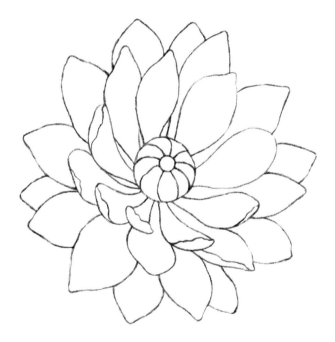

Plan out your art on a separate piece of paper. Once you've created a design, use the guidelines I've provided to help you transfer your sketch into this book for painting.

2

PLANNING YOUR COLOR

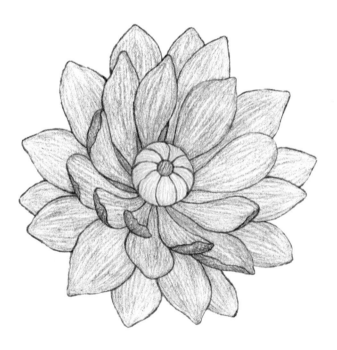

Consider your color palette in the same way that you did with your composition sketch. Decide which tones you'll use and where—that way you can put all your focus on technique when you start to paint.

3

PAINTING IN ORDER

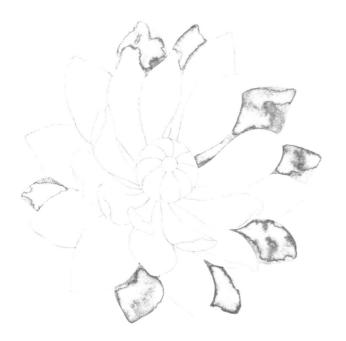

Paint from easiest to hardest element—this will warm up your hand. I started with the larger outer petals, working inward. This way, I'm layering the forms on top of each other in the same way as they are seen in nature. Choose what feels best for you.

4

FINALIZING YOUR ART

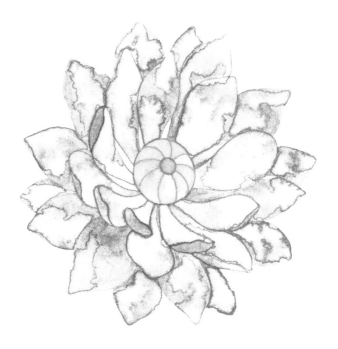

Touch up your blooms, refining any rough edges or spotty areas as the paint dries. Once the art is completely dry, carefully erase your guidelines with a kneaded eraser to finish your design.

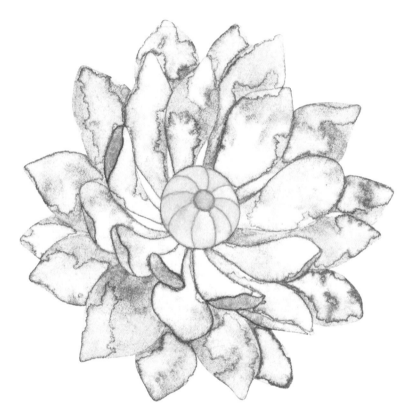

MANGANESE BLUE, ULTRAMARINE, VIVID GREEN & CADMIUM YELLOW
ROUND, 0 & 3

TECHNIQUE

Next, let's paint your own bloomy blossom. Work out your palette in advance of painting and start by painting the petals in the background first. Work towards the center, layering the forms on top of each other. As the paint dries, revisit areas you've worked on with a clean, wet brush to develop your blooms. Paint all of one color before moving onto the next. Finalize your art by refining any rough edges or spotty areas.

TIP

When creating a painting composed of different sized elements, remember that not every area needs to be textured. It can be difficult to develop blooms in smaller shapes and having a smooth shape to contrast a textured one can enhance your work and add depth. Keep this in mind as you pick and choose where you want to use blooms your design.

TECHNIQUE

Now we'll paint a geometric study. Think about how these sharp geometric shapes will contrast with the organic bloom texture. Fill in each shape, starting in one corner and working your way across the form. Transition between colors as you go and as each form starts to dry, go back and develop the blooms.

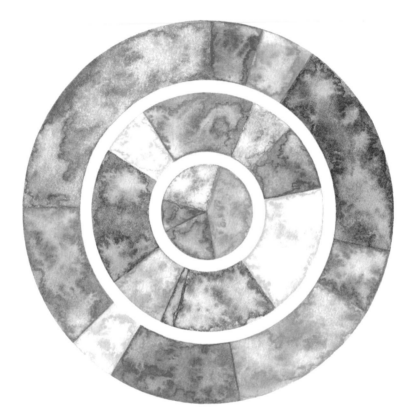

OPERA ROSE, WINSOR ORANGE, NAPLES YELLOW.
ROSE DORÉ, BURNT SIENNA & RAW SIENNA
ROUND, 0

TIP

When combining several different shades onto a single element of your painting and then developing blooms in that same space, be careful to make those blooms using clean water. This will keep the colors as distinctive as possible. Using dirty water will muddy the art by blending your colors further together.

TECHNIQUE

Now, let's create an organic tree ring composition. Again, plan out your palette before starting. Work from the outer ring toward the center, developing blooms as you go. While this entire piece will be all in shades of brown, you can add variety with lighter and darker tones, subtle mixes of warmer and cooler browns, and contrasting textures. Refine your art by tweaking any problematic blooms, smoothing any edges, and touching up any spotty areas.

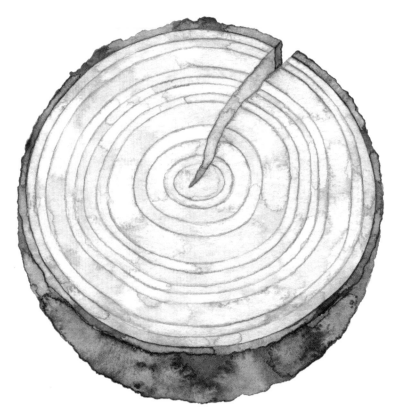

BURNT UMBER, RAW SIENNA, DAVY'S GRAY & PAYNE'S GRAY

ROUND, 0 & 3

TIP

Texture can differentiate areas of a design just as effectively as color. When working on a painting like this one that uses similar tones across the entire piece, find ways to utilize texture to create distinction and contrast between the shapes.

TECHNIQUE

Here we'll do a liquid lettering piece. Plan out your design with light graphite guidelines. I recommend arranging your letters first, then placing droplets around them. Consider your colors in advance of painting. As always, paint from the simplest shape to most complex—here I started with the small individual water droplets to warm up my hand. Fill in each element with your mix of shades and develop blooms as they start to dry. Refine any problem spots to complete your painting.

INTENSE GREEN, TURQUOISE & MANGANESE BLUE
ROUND, 0 & 3

TIP

When creating dimensional paintings, you can add a 3D feel by nudging additional pigment to the edges of the shape. This will make the forms lighter in the center and darker around the edges, mimicking how light looks when it hits an object from above. To create this aesthetic, add a bit more water to each area right after you fill them in. Applying water to your wet paint like this will effectively push the pigment to the edge.

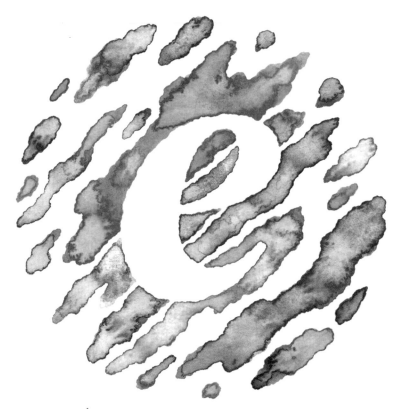

ROSE DORÉ, CADMIUM RED, ALIZARIN CRIMSON, MAGENTA COBALT,
ULTRAMARINE VIOLET, PERMANENT MAGENTA & COMPUT MORTUUM
ROUND, 0 & 3

TECHNIQUE

Finally, let's paint some motion inspired lettering. I'm focusing on a single letter for this piece—the letter "e." I chose an italicized font to accent the movement of the pattern behind it. To start, sketch out your type and then develop the design around it. Consider your color selection before painting. Paint all of each color mix before moving onto the next, and as each tone dries, brush on extra water to develop the blooms. Refine the design, touching up any problem spots, to finish.

TIP

Be careful not to overwork the blooms. If you try to push them too far, you may end up washing them away completely instead of enhancing them.

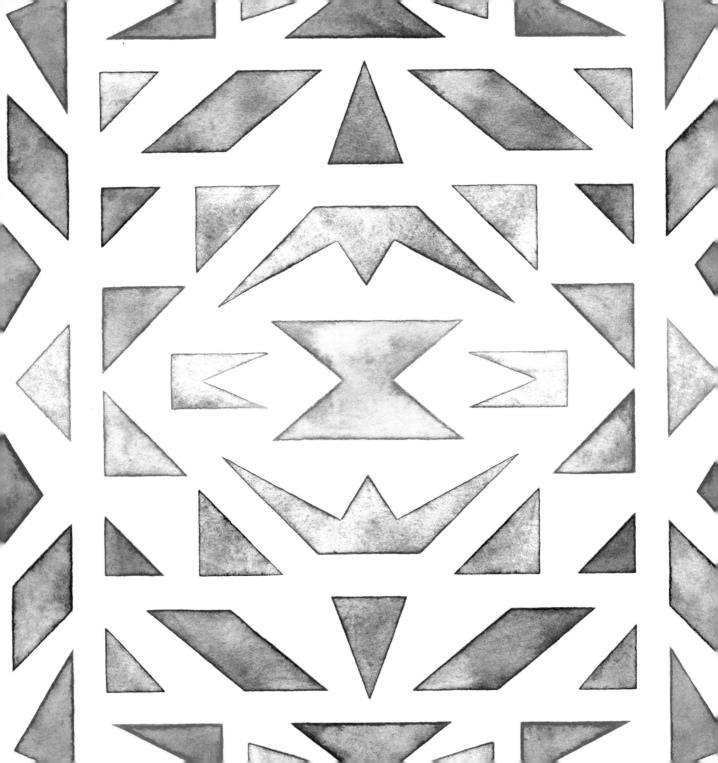

FLAT WASH

TECHNIQUE

GETTING STARTED WITH FLAT WASH PAINTING

An approach that creates smooth colored surfaces

In the previous chapter, we learned how to develop blooms of texture with our paints. Now, we shift our focus to making smooth, even surfaces. Not every concept calls for intense movement and texture within the pigment—sometimes you want a more restrained, clean aesthetic. In these instances, a flat wash approach will create the result you are looking for. This is a particularly technical and often tricky skill that takes practice to get right, so don't be discouraged if it takes time.

1

PREPARING TO PAINT

Start just like you would for any other painting: plan out your design with a sketch. From there, develop light graphite guidelines on your page to follow while painting. Consider your color palette in advance, and mix your first pigment.

2

APPLYING PAINT TO PAPER

Brush your pigments onto the page, starting on one end of your form, and moving to the other, carefully zigzagging your brush across the shape while keeping your edges defined. You may have to return with fresh water to keep everything wet. Once you have finished filling in the entire form, you will then take steps to keep the pigment smooth as it dries.

3

REFINING YOUR SMOOTH SURFACE

Now that you have painted the entire shape, go back with a clean brush to smooth out any developing texture. There may be excess water in your painting that can puddle and cause problems. In that case, take the right edge of the page and roll it towards the spine to make a loose "U" shape. Carefully rock the page back and forth to gently move the water across the surface and disperse the watery pigment evenly. You may need to pick up the sketch book to maneuver it fully. Hold that "U" shape until the pigment is just barely damp, then go ahead and put the page down flat to let it fully dry.

4

COMPLETING YOUR ART

It's particularly important to let the paint dry completely before applying any touch-ups when creating flat washes because adding water to your art while it is still damp can create textures we are working to avoid. Once your art has dried, make as few touch-ups as possible. If you do need to make any fixes, work with mainly pigment, using as little water as possible.

BURNT SIENNA
ROUND . 3

INTENSE GREEN
ROUND . 3

TIP

Some pigments are better suited to developing flat washes than others. When testing different pigments you may discover that some soak into the page more developing "shadows" that are hard to manipulate. Other pigments stay more on the surface, allowing you to smooth them more completely.

TECHNIQUE

We'll do ten experiments using this flat wash technique, beginning with some single color swatch tests. Similar to the bloom technique, paint from one corner of the form, zigzagging your paint across the swatch. Keep your paint flowing to avoid developing any hard lines. Continue to go back into the areas that are already painted with fresh water to keep everything wet. Once you have filled the entire form with pigment, go over the shape once more with a clean wet brush to smooth out any ripples and clean up any rough edges. Gently roll your page into a slight "U" shape to smooth out the page and start carefully moving any liquid on the paper's surface back and forth to avoid puddling. Once the paint has completely dried, go back in with as dry a brush as possible to correct any minor issues to finalize your test.

CADMIUM RED & PERMANENT MAGENTA
ROUND, 3

TIP

When painting flat washes, if you need to correct something, it is best to brush over the entire area you're working on, rather than trying to fix a small portion of the painting. This may seem counterintuitive, but as seen in the previous bloom chapter watercolor paints can have dramatic reactions to water. If you want a smooth finish, you have to work the whole surface as one.

COBALT BLUE & CAPUT MORTUUM
ROUND, 3

TECHNIQUE

Now we'll continue our flat wash technique swatch tests with some two-color experiments. Select your paint colors in advance of starting. Here I've used two similar hues on the top swatch and two more contrasting hues in the bottom. Zigzag your brush across the surface filling in the form and keeping the paint flowing as you go When you're ready, transition between your colors. Keep the paints damp by brushing clean water across the surface. Once you have filled in the entire form, use more clean water to smooth out any developing texture. If any puddling starts to appear, carefully bend the paper into that "U" shape and gently move it back and forth to redistribute any excess liquid. Once the paint has fully dried touch up any minor issues to complete your swatch.

TURQUOISE, ULTRAMARINE VIOLET & PAYNE'S GRAY
ROUND, 3

RAW SIENNA, MANGANESE BLUE & ULTRAMARINE
ROUND, 3

TIP

If you need to make any minor corrections in an area of flat wash paint, wait until the pigment has fully dried. This will help ensure that the paint does not develop blooms. Focus on correcting your edges and avoid painting areas in the middle of a flat washed element as these types of corrections will be hard to blend into the rest of the painting.

TECHNIQUE

Next, we'll practice the flat wash technique with three pigments. Consider your color palette in advance of painting. This technique can create extremely subtle transitio from color to color. If you pick similar hues, such as in my first swatch here, the colors will run togethe in a uniquely subtle way. Transition between colors as you paint across the form and brush fresh wate into the test to keep the entire area damp. Once yc have filled in the whole form, smooth out any developing texture. If you need to, bend the page in that slight "U" curve to smooth the painted surfac as it dries.

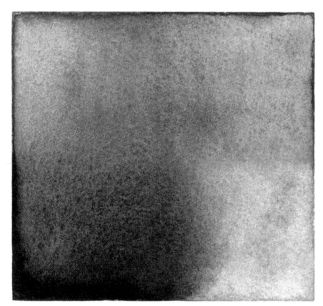

BURNT SIENNA , BURNT UMBER , IVORY BLACK & DAVY'S GRAY
ROUND . 3

TIP

While rocking any excess water across the page, pigment will start to shift as well. To keep your color bright and distinct focus on moving this excess water in the same direction you painted as much as possible. For example, I moved the water at a diagonal to keep the reds, oranges, and pinks visible in the lower swatch on this page.

TECHNIQUE

Let's now try painting with four pigments in a single swatch. Plan out your palette in advance of painting. Consider the composition of colors in your swatch—you don't have to create straight lines of color. Try applying the paint in other patterns such as a group of squares like I did in the top swatch or triangles like the lower swatch. Work your way across the shape and keep the pigments flowing as you transition between colors. Once you have filled the entire form, brush it again with fresh water to smooth out any texture. Manipulate the page into a soft "U" shape to smooth out the paper, and roll the liquid back and forth to keep it from puddling while the swatch dries. Make any minor touch ups once the paint is completely dry.

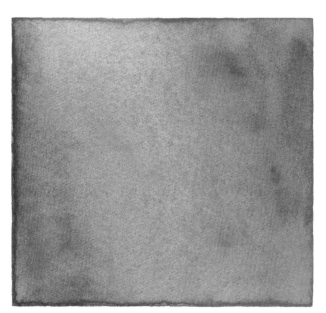

ALIZARIN CRIMSON , WINSOR ORANGE , OPERA ROSE & SCARLET LAKE
ROUND . 3

TIP

If a hard line starts to develop while you're painting a swatch, go back and work that pigment with a damp brush. By brushing over that spot repeatedly you can loosen the pigment up and smooth out that area of paint.

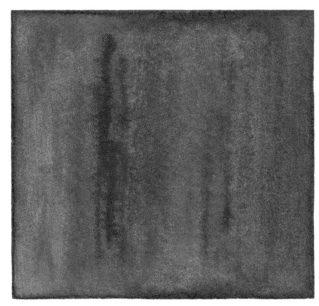

ULTRAMARINE VIOLET, CAPUT MORTUUM, PERMANENT MAGENTA
OPERA ROSE & BURNT SIENNA, ROUND, 3

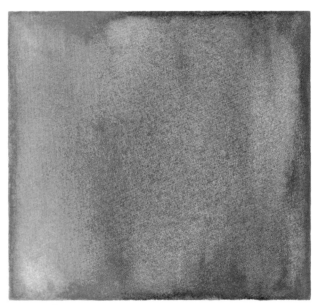

ROSE DORÉ, OPERA ROSE, COBALT BLUE, TURQUOISE
& CADMIUM RED ROUND, 3

TECHNIQUE

Finally, let's try some swatch tests where we combine five pigments in a single form. Again, think through your color selection and the arrangement of those colors befor painting. Try different approaches such as brushing stripes on top of areas of wet paint, shown in the upper swatch on this page. Any color arrangement you make will be smoothed ou as we create the flat wash Start on one corner of your form brushing each color into your shape. Keep the paints damp all the way across the form, brushing them with clean water as you go. Once you have fille in the entire shape, smoot out the pigment with a litt more water. If you need to, form the page into a loose "U" to smooth the wet paper, and rotate the page around to keep any excess surface liquid from pooling Once the test is completel dry, touch up any areas wi a dry brush to finish the a

MERGING SKILLS & IDEAS

Now that you have practiced painting flat washes, let's apply the technique to compositions. We start off with a geode, exploring how paint can simulate the smooth surface of this layered rock. From there, we will do a neat geometric study, a graphic interpretation of a landscape, and more!

A WORK IN PROGRESS

1

SKETCHING AND GUIDES

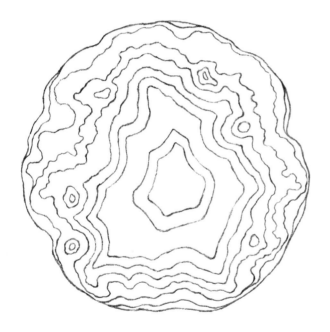

Design your composition, starting with a sketch. You can use the guidelines I've provided as a starting point. Once you've filled in the details you want, draw light, graphite guidelines on your painting surface page to reference as you go.

2

PLANNING YOUR COLOR

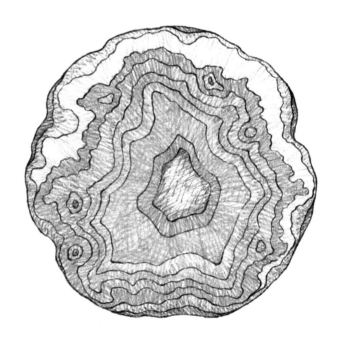

Plan out your color palette on your sketch before you start applying paint to your design. This will allow you to focus solely on technique when you do start to paint.

3

PAINTING IN ORDER

Paint each layer of the geode using the flat wash technique, starting with the outermost layer and work inward. This way you only have to perfect one edge of your shape at a time.

4

FINALIZING YOUR ART

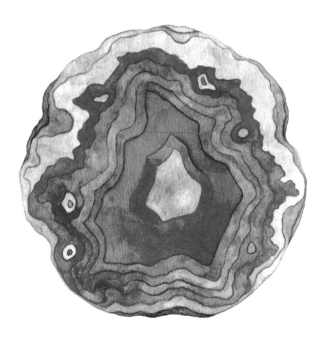

Complete your painting, refining any spots and rough edges as you go. Remember, try to do as few touch-ups as possible when working with flat washes. Once the art has completely dried, gently erase any visible guidelines with a kneaded eraser.

TECHNIQUE

Now you'll paint your own geode slice. Start with a sketch and light graphite guidelines. Consider your color palette in advance of painting. Work from the outer layers in, painting each flat wash surface and correcting any issues as you go. Finalize your art, making any minor touch-ups once the entire painting is completely dry.

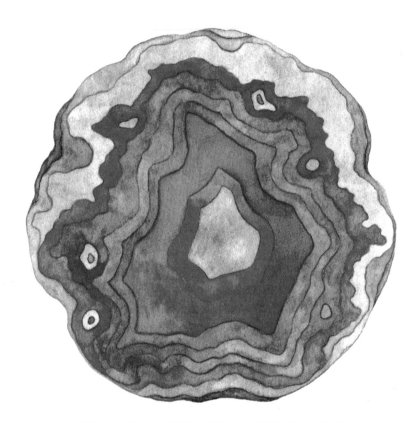

CADMIUM RED, ALIZARIN CRIMSON, DIOXAZINE VIOLET,
PERMANENT MAGENTA, ULTRAMARINE, RAW SIENNA, BURNT UMBER,
BURNT SIENNA, DAVY'S GRAY & PAYNE'S GRAY
ROUND, 0 & 3

TIP

Once you have painted the entire geode study, you can smooth out any dark edges of concentrated pigment and enhance the glassy feel of your piece by painting clean water across the entire design. This will also blend the color palette together a little bit more, further unifying the art. Let your painting set for at least a day before doing this, otherwise the pigments may move around too much and muddy your design.

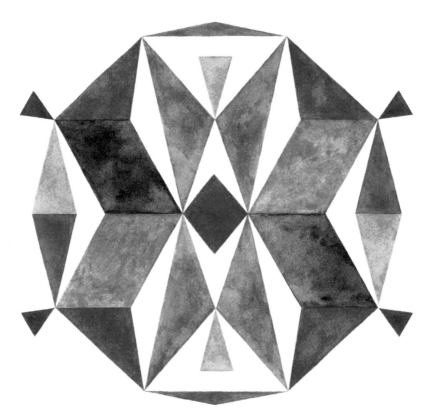

ALIZARINE CRIMSON , PERMANENT MAGENTA , MAGENTA COBALT ,
MANGANESE BLUE , ULTRAMARINE , BURNT UMBER & BURNT SIENNA
ROUND , 0

TECHNIQUE

Let's now paint a decorative geometric arrangement. Plan out the details of your design with a sketch and draw guidelines to start. Think through your color selection and mix any necessary shades. Paint all of one color before moving onto the next, refining each element as you go. Finalize your art by touching up any problem spots once the entire painting has dried.

TIP

When painting smaller areas of flat wash, like you will here, you don't need to worry as much about the extra liquid on the papers' surface puddling. Instead, this water can be an asset—adding a bit more liquid to your painted elements and then letting them dry flat will push extra pigments to the edges, continuing to smooth out the painted surface.

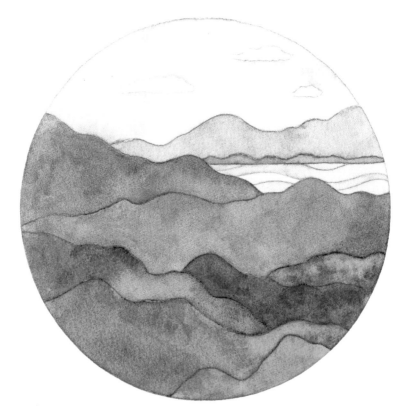

BURNT SIENNA , INTENSE GREEN . ULTRAMARINE & MANGANESE BLUE
ROUND , 0 & 3

TECHNIQUE

Now, let's move on to a graphic landscape piece. Using graphite, develop subtle guidelines to follow while painting. Think through your palette. Consider using cooler colors in the distance and warmer colors in the foreground. Paint the background first and move forward—in this case start with the sky, distant mountains, and water, and then move to the layered mountains in front. This will keep each element on the correct plane of the painting. Touch up any minor problem spots to complete your painting.

TIP

When painting larger areas such as backgrounds for landscapes, try using a different approach to create your flat wash. Tilt your page slightly, and brush even strokes of overlapping pigment in a downward direction, one after the other, until you fill the entire form. Leave this to dry, creating a large area of smooth painted surface. Keep in mind that you will have less control over the edges unless you use a masking medium such as artists tape or masking fluid (see pg. 177).

TECHNIQUE

Next we'll paint some stencil-style lettering using graphic shapes. Once you plan out your design with light graphite guidelines, think through your color selection. Paint all of one tone before moving on to the next. Correct any issues as you go. Once you've finished painting, touch up any minor problem spots with as dry a brush as possible and erase any visible guidelines to complete your study.

COBALT BLUE, MANGANESE BLUE & WINSOR ORANGE
ROUND, 0

TIP

When touching up areas of your painting after it has completely dried, try dotting on pigment instead of brushing it on. This will disrupt the flat washed surface much less and blend better with the rest of your painting.

TECHNIQUE

Finally, we'll do a bold, monochromatic type study. I'm focusing on a single letter for this piece—in this case the letter "Z." Again, plan out your composition with light guidelines and think through your color selection. In this study, I played with different tones of gray. The Z in the center of the painting is the darkest shade and I used progressively lighter tones as I moved outward toward the edges of the composition, creating a stylized ombré effect. Work through each element of your painting, correcting issues as you go. Do any minor touch-ups at the end and erase your graphite guidelines to finalize your art.

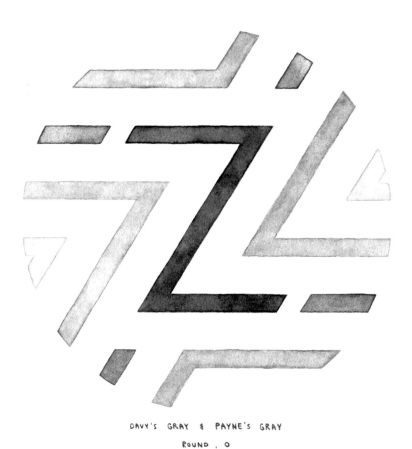

DAVY'S GRAY & PAYNE'S GRAY

ROUND, 0

TIP

When painting an area of flat wash, try to correct as many issues as you can while the paint is as wet as possible. Very wet paint won't be disrupted by the addition of more water and it will blend more easily with newly introduced pigment.

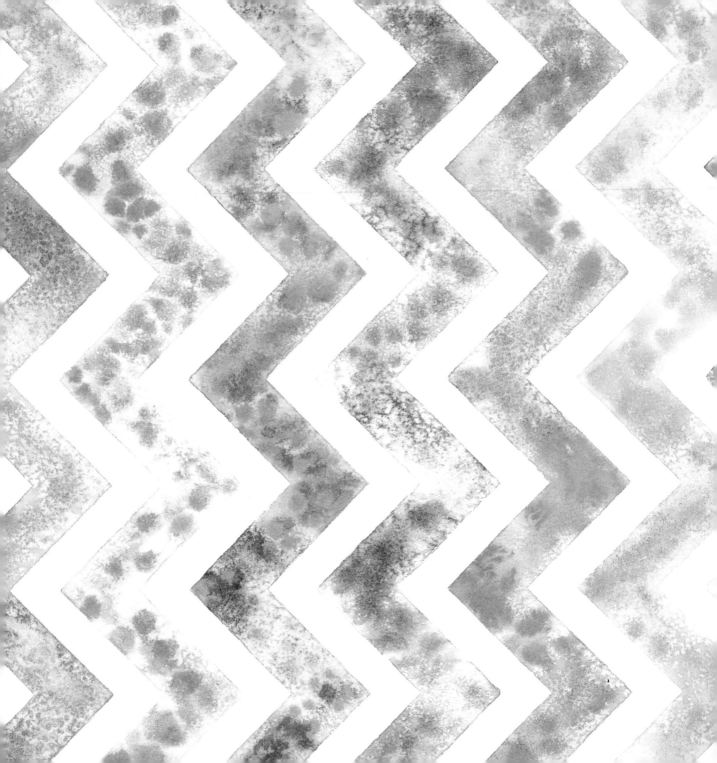

LIFTING
TECHNIQUES

GETTING STARTED WITH LIFTING STYLES

Approaches to removing pigment from paper

Now we'll start exploring some more specialized approaches to the watercolor medium. In this chapter, we will play with a selection of the many lifting techniques used to remove pigment from paper, exposing either a lighter shade of paint or the white of the page. These techniques include using a damp brush to loosen and wash away areas of pigment, the introduction of salts, manually scraping paint using a blade, and working with masking fluid. Each of these methods can introduce definition and texture to your paintings.

1

USING A DAMP BRUSH

Once you have painted an area of your design, take a brush, dampened with clean water, and start pulling it back and forth across the area of pigment that you wish to lighten. Repeat this step until you have loosened and washed away as much paint as you desire. Let the painting completely dry and finalize the art just as you would with any other piece.

2

INTRODUCING VARIOUS SALTS

Apply pigment to an area of your composition, adding a bit of clean water over the top to keep the entire element damp. Sprinkle salt onto your design and watch as the salt absorbs the water (and the pigment) to create unique textures. Different salts will make different patterns. A finer table salt will develop a more delicate and consistent texture, in comparison to a coarse sea salt's heavier and more random textures. Let the paint fully dry and brush off any excess salt to refine your design.

3

SCRAPING WITH A BLADE

Another skill we experiment with in this chapter uses an X-Acto knife to carefully scrape pigment off the page. Consider your composition in advance. Begin by painting a portion of your design and letting it dry. Once the pigment has fully dried, take your blade and gently scratch the paper's surface to remove bits of paint. Do not press too hard on the page, otherwise you may develop holes in the paper. Once you have completed the scraping process, brush the surface clean to finalize the art.

4

WORKING WITH MASKING FLUID

Masking fluid is one of the more fussy mediums we will work with in this section. Plan out your design with light graphite guidelines and carefully paint masking fluid into the areas of the composition that you wish to leave white (a.k.a. the color of the paper). Let the masking fluid dry completely and then paint your art as you normally would. Once the painting is finished and the pigment has fully dried, go back into the art with a rubber cement pick-up tool to remove all masking fluid from your design.

CHROME YELLOW
ROUND , 3

TECHNIQUE

We'll start with the damp brush technique and use our green and yellow pigments. Paint your swatch using the wet on dry technique and allow it to fully dry. Consider the design you want to develop on the painted surface. Here I've decided to create a dotted texture. Take a clean damp brush and paint your design into the pigment. The added water will push the underlying paint off the page to create your desired design

TIP

Different pigments react in varying ways to this damp brush lifting technique. Some will come up easily while others may not budge. Consider your pigment choice carefully when planning for this approach. Paints that soak into the page and leave "shadows" such as Indigo (see pg. 28) may not work as well with this technique.

INTENSE GREEN & GAMBOGE
ROUND , 3

TECHNIQUE

Now this time let's combine the lifting technique with wet on wet painting. Fill your swatch with water and pigment as you normally would. Allow your painting to completely dry. Take a clean damp brush and paint the surface with your desired design (here I've used stripes). Repeat this step several times to remove enough pigment, revealing your "lifted" image.

WINSOR ORANGE
TABLE SALT & ROUND, 3

TECHNIQUE

We'll continue our lifting technique tests with salt and our orange and red pigments. Here I've used the wet on dry painting technique in combination with table salt. As you paint, be careful to keep the entire area damp, adding some additional clean water as you go. Once you have finished filling the shape, sprinkle the salt across your surface. Let it completely dry and brush off any crystals to finalize your swatch art.

TIP

Table salt leaves an extremely delicate and subtle texture on the paper's surface. Because it is so soft, this technique works best with darker pigments. Lighter pigments such as yellows won't showcase this texture as well.

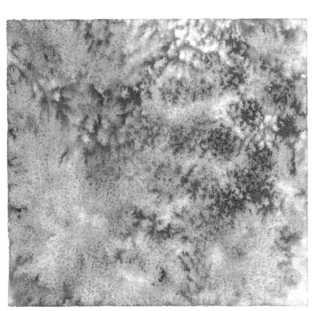

ALIZERIN CRIMSON & OPERA ROSE
TABLE SALT & ROUND, 3

TECHNIQUE

Now, let's try using table salt with the wet on wet technique. Just as before, paint your swatch using the standard approach. Make sure to keep the pigment completely damp before sprinkling salt across its surface. Allow the paint to fully dry and brush any leftover salt off of your painting to complete the test.

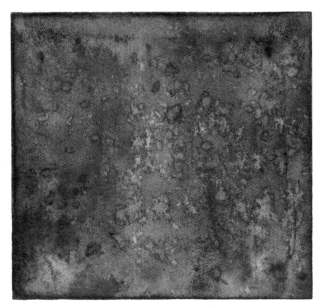

PERMANENT MAGENTA
SEA SALT & ROUND . 3

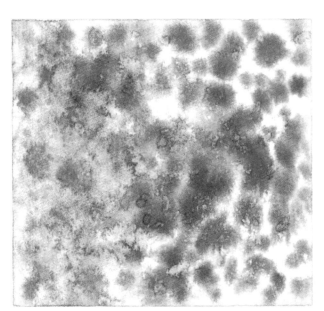

ULTRAMARINE & DIOXAZINE VIOLET
SEA SALT & ROUND . 3

TECHNIQUE

Next, we'll practice with sea salt and our purple and blue pigments. Paint these swatches as you normally would and make sure to keep your painting damp by adding extra clean water to its surface. Once you have fully painted the swatch, sprinkle salt across it. Allow the painting to completely dry before brushing off leftover crystals.

TECHNIQUE

Experiment with how salt interacts with a painted texture. Here I've used wet on wet to create a dotted arrangement of pigments. Make sure to keep the entire form damp and sprinkle the salt across its surface. Once it's fully dry, brush any extra salt crystals off the page.

TIP

It can be hard to brush off every little crystal caught on the paper's surface once it's dry. This will leave the page a little rough to the touch. Be careful if you choose to scan this salt-coated art into the computer, as it could potentially scratch your scanner bed.

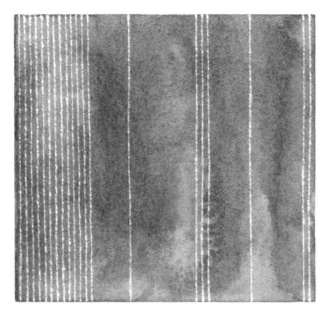

BURNT SIENNA
X-ACTO KNIFE & ROUND , 3

TECHNIQUE

Now, let's paint with our black and brown pigments and incorporate the lifting technique known as scraping. Paint your entire swatch and allow it to fully dry. Visualize the design you wish to create in the surface of you pigment. Here I've used an arrangement of lines across the swatch. Using the sharp point of your X-Acto knife, gently scratch the paper's surface to remove pigment. Brush the surface clean to complete your painting.

TIP

Just like with the damp brush lifting technique, not every pigment will react the same way to the scraping technique. Some colors will be harder to carve decorations into than others because of how they adhere to the paper. Some pigments stay on the surface while others soak into the page. Let the pigment fully dry, but don't wait too long. The longer you wait, the harder it can be to remove the pigment cleanly.

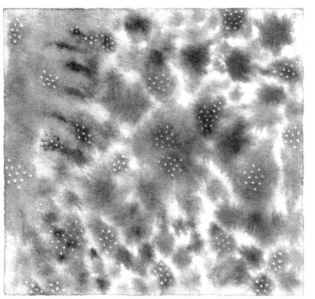

PAYNE'S GRAY & BURNT UMBER
X-ACTO KNIFE & ROUND , 3

TECHNIQUE

Let's also create some swatch tests where we combine scraping with the wet on wet technique. Again, paint the swatch as you normally would using your black and brown pigments. Allow the art to fully dry, and consider the design you wish to create in the painted surface. In this swatch, I created groupings of small dots. Gently scrape the paper to remove all desired pigment. Brush off the paper's surface to complete your swatch test

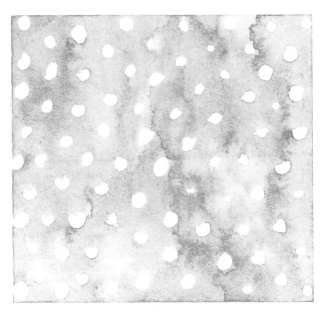

TURQUOISE & CHINESE WHITE
COTTON SWAB , MASKING FLUID . RUBBER CEMENT PICK-UP & ROUND . 3

TECHNIQUE

For this final set of swatches, we'll work with masking fluid and our white and neutral tint pigments. Consider your design and apply the masking fluid to your page. You can brush it on, or dot it with cotton swabs, as I did for this light blue test. Let the masking fluid fully dry and then paint as usual. Once your painting is complete, remove the masking fluid with a rubber cement pick-up tool.

TIP

Masking fluid can ruin your brushes so use your cheapest ones for this technique and be sure to clean them immediately when you've finished. Alternatively, you can follow my lead and use less conventional application approaches: I used cotton swabs and tooth picks for these tests.

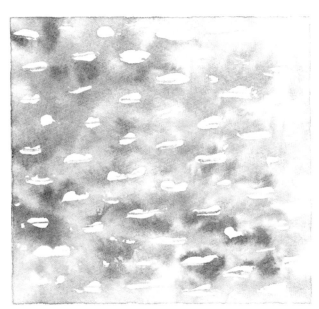

INTENSE GREEN, CHROME YELLOW & NEUTRAL TINT
TOOTH PICK, MASKING FLUID . RUBBER CEMENT PICK-UP & ROUND . 3

TECHNIQUE

Finally, let's try some white and neutral tint swatch tests where we use masking fluid and the wet on wet approach. First, paint the masking fluid onto your page. You can try using a tooth pick, as I did for this green and yellow test. Once the masking fluid is dry, paint as you normall would. When the paint is dry, use a rubber cement pick-up tool to remove the masking fluid from you art, completing the swatch

MERGING SKILLS & IDEAS

Now that we've had a chance to play with several different lifting techniques, let's apply these skills to compositions. We'll use the damp brush lifting approach to enhance delicate feathers, add salt to a graphic geometric design to develop contrast, use scraping to add tribal inspired elements to lettering work, and more!

A WORK IN PROGRESS

1

SKETCHING AND GUIDES

Figure out the details of your composition with a sketch. I've provided guidelines for you to start with. Use that drawing as reference to fill in the light graphite guidelines you will need to start painting.

2

PLANNING YOUR COLOR

Think through your color palette before you start painting. Mix any pigments you need to get going.

3

PAINTING IN ORDER

Start by painting the entire design. In this case, I'm developing different textures, ombré effects, and patterns to add interest to each of the feathers.

4

FINALIZING YOUR ART

Once all of the feather paintings have dried, I'll use the damp brush technique to develop soft line details. Finalize your painting, touching up any spots and gently erasing any visible graphite guidelines.

TECHNIQUE

Now you'll make your own feather composition using the damp brush lifting technique. Plan out the details of your design with light guidelines, and consider your color schem Paint the feathers using your desired technique— here I've used wet on dry and ombré. Allow them to fully dry then go back with a clean damp brush t define the delicate texture of the feathers' individual hairs. Refine your art, touching up any spotty areas and rough edges, to complete the study.

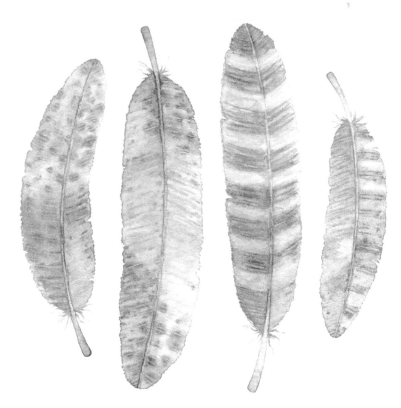

INTENSE GREEN , VIVID GREEN , COBALT BLUE & BURNT UMBER
ROUND , 0 & 3

TIP

The damp brush lifting technique is most easily executed when your art is freshly painted. You will need to wait until the design is completely dry to avoid blooms, but don't let it "set" too long. The longer you allow the pain to sit untouched, the less you will be able to manipulate it when you g back in with a damp brus

TECHNIQUE

Next let's paint a study of bold geometric shapes and incorporate table salt to add contrasting texture. Consider your palette in advance of painting. Paint each stripe of this design—in this case I used the wet on wet technique. Keep each stripe damp, adding a little extra clean water as you go. Sprinkle salt across each stripe to develop texture and allow to fully dry before moving onto the next one. Brush off any extra crystals, and touch up any spots to finalize your design.

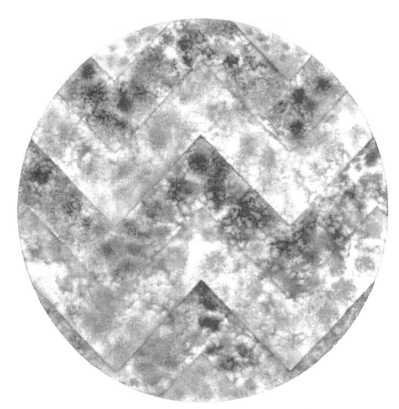

WINSOR ORANGE, SCARLET LAKE, ROSE DORÉ,
ALIZARIN CRIMSON & CAMPUT MORTUUM
ROUND, 0 & 3

TIP

If the paint starts to dry before you can add the salt take the time to go back and fully wet the surface. Dry paint will not react to the addition of salt, so keeping the paint damp is an extremely important part of this process.

TECHNIQUE

Now, let's do a furry animal study, incorporating the sea salt lifting technique. I chose to paint a balled up hedgehog! Using the wet on wet painting technique, fill in each section of fur. Sprinkle salt onto the damp paint and allow it to dry before moving to the next section. Once the art dries, brush off any extra salt crystals. Define the eyes and nose using the wet on dry painting technique. Refine the art, touching up any spotty areas and erasing visible graphite guidelines.

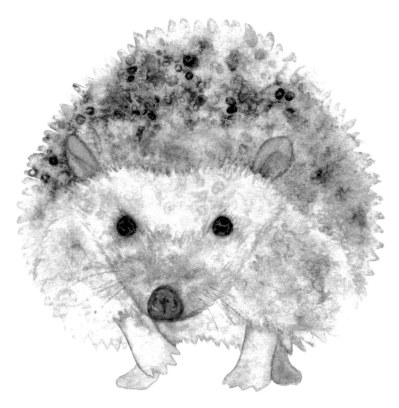

DAVY'S GRAY , PAYNE'S GRAY , IVORY BLACK ,
BURNT UMBER , BURNT SIENNA & RAW SIENNA
SEA SALT & ROUND 0 & 3

TIP

Sea salt is less predictable than table salt because of its irregularly shaped crystals. Only use this salt when you want a rough, more pronounced texture in your design. In this case I chose the sea salt to recreate the spiny fur-like texture of this hedgehog.

TECHNIQUE

Here we'll explore lettering using scraping. I'm focusing on a single letter—"X" for this study. Sketch out your design with light guidelines and consider what colors will enhance your design. I chose to use the wet on dry approach for this piece. Let the paint fully dry, and using the sharp point of your X-Acto knife, carefully scrape bits of the pigment away, creating a tribal inspired design. Brush away any scraps of pigment to finish your art.

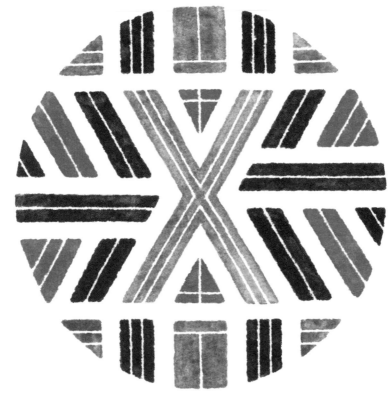

CADMIUM RED, IVORY BLACK & BURNT SIENNA

X-ACTO KNIFE & ROUND, 3

TIP

Scraping can be used to define areas of a design, but it can also be used to develop an overall texture. In this case, I wanted to create an archaeologically-inspired aesthetic and chose to use scraping to develop a more worn texture across the entire graphic.

TECHNIQUE

Finally, let's paint a textured lettering study using masking fluid. Plan your design with subtle guidelines. Apply the masking fluid to create an intricate textured effect. You could also use the masking fluid to create your letter. For this piece, I used tooth picks to apply the medium. Once the masking fluid has dried, paint as you normally would. Here I chose a wet on wet, dotting and striping approach to enhance the pattern. Allow the paint to fully dry and finalize your art, using a rubber cement pick-up tool to carefully pull the masking fluid off the page.

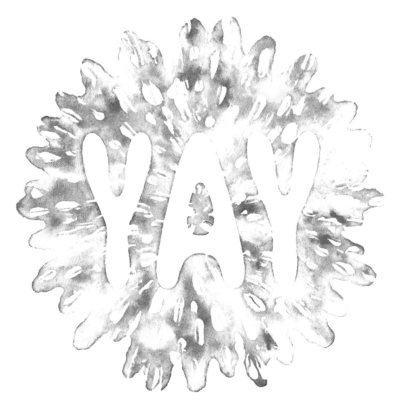

INTENSE GREEN, CADMIUM YELLOW & MANGANESE BLUE
TOOTH PICK, MASKING FLUID, RUBBER CEMENT
PICK-UP & ROUND 0 & 3

TIP

Be mindful not to heat masking fluid. Some peopl like to use a hair dryer on wet paint to speed up the drying process, but this will have negative effects when working with maskin fluid. Also, be careful to remove the masking fluid from your design as soon as you have finished your painting and it has fully dried. If you are not attentive when working with this medium, it can adhere to your art permanently.

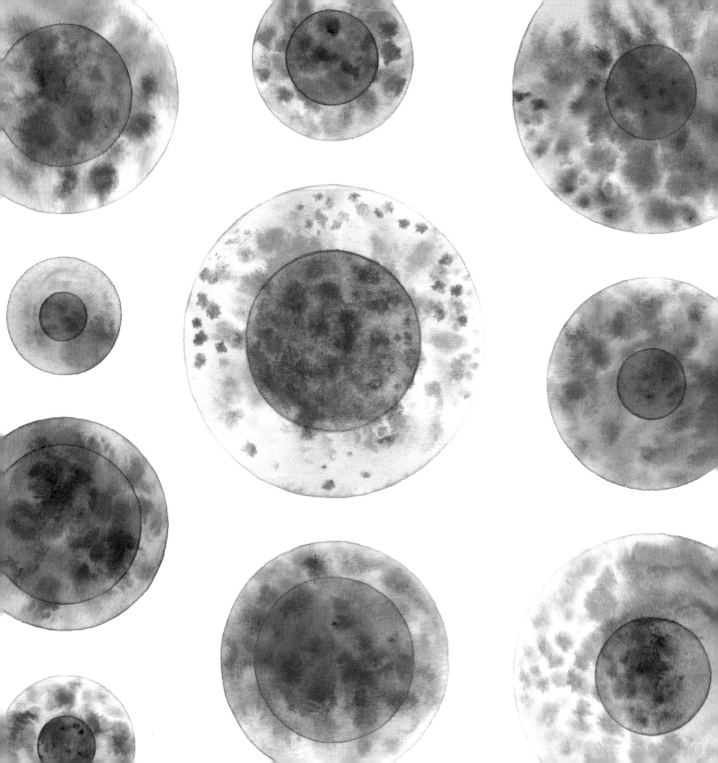

LAYERING
TECHNIQUES

GETTING STARTED WITH LAYERING STYLES

Techniques to add design elements on top of paint

An alternative to lifting techniques are layering techniques. Sometimes you want to add design elements and textures on top of your watercolor paintings to enhance your vision. This chapter will cover several of the many layering techniques available, including mixed media, layering paint on paint, incorporating dry brush marks, and the use of stamping to create texture.

1

PLAYING WITH MIXED MEDIA

Mixed media can include anything, from incorporating collage to drawing with graphite to layering pen and ink. This gives you a chance to find the mediums that you enjoy and bring them together with watercolors. Develop a concept that allows each material to shine. Sketch your design to get started and consider which medium should be applied to the paper first. Do you want to paint over collage? Do you want to ink on top of paint? The possibilities are endless.

2

LAYERING PAINT ON PAINT

When layering paint on paint, plan the design with this technique in mind. Paint the first layer of the design as you normally would and allow this paint to "set." I personally won't start a second layer of paint until the next day. This way, you won't brush away the first layer when you start to apply the second layer.

3

INTRODUCING DRY BRUSH MARKS

The dry brush technique shows off each stroke of the brush, creating a sense of movement, while also developing unique textures. Once you have painted the base layer of your design, take a brush loaded with pigment and as little water as possible. Pull it across your painting or stipple it onto the page. The variations with this technique are endless.

4

INCORPORATING STAMPING EFFECTS

Stamping is another way to introduce texture to your painting. This is an opportunity to take found objects with interesting patterns such as natural and synthetic sponges and utilize them within your design. Once the first layer of your design is complete and dry move on to the stamping. Take your textured object, apply paint to it, and then press it on the page.

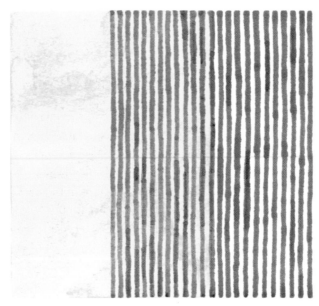

CHROME YELLOW
PEN & ROUND , 3

TECHNIQUE

We'll start with some swatch tests in our green and yellow pigments using pen and ink mixed media. I used felt tipped pens and the wet on dry technique here. Paint a portion of the swatch in the same way you normally would and allow the paint to completely dry. Then layer a pe and ink pattern over part of the painting and fill in the rest of the swatch. The overlap will allow you to compare all three textures next to each other.

TIP

Pen and ink is one of my favorite mediums to layer with watercolor, but you should be careful when the two mediums combine because the water in the paint can push the ink around, potentially messing up your design. I prefer to paint first, let everything dry, and ink second. This ensures that each layer of my design will stay in place.

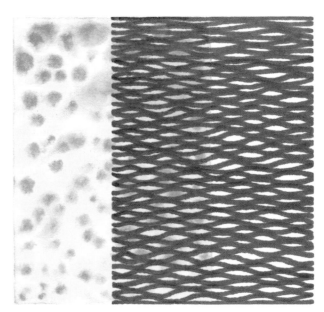

CADMIUM YELLOW & VIVID GREEN
PEN & ROUND , 3 & 0

TECHNIQUE

Now let's use our green and yellow pigments in a different arrangement. I've used wet on wet to create a dotted pattern. Fil part of your swatch with water and pigment as you normally would. Allow the painting to fully dry and draw a design with pen and ink over part of the painted area, while also filling in the rest of the swatch.

TECHNIQUE

We'll continue our layering technique tests, this time using our orange and red pigments with graphite mixed media. Fill in a portion of the swatch with pigment and allow the paint to fully dry. Here I've used a subtle variation of the bloom technique. Draw a design over part of the painted surface and fill in the rest of the unpainted swatch with your pencil work.

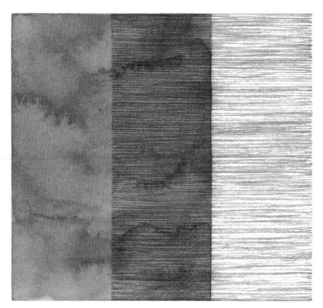

SCARLET LAKE
PENCIL & ROUND, 3

TIP

Graphite generally looks best when layered on top of or next to watercolor. It's hard to place this medium under a painting. The introduction of water, in combination with the brush's back and forth movement across the page will easily lift away penciled designs, obscuring or erasing the art.

TECHNIQUE

Try experimenting with directionality like I've done here. Paint part of your swatch moving consistently in one direction. Once it has dried, apply a graphite design in an opposing direction to the painted area. Clean up any areas of your drawing that need refinement to finalize this art.

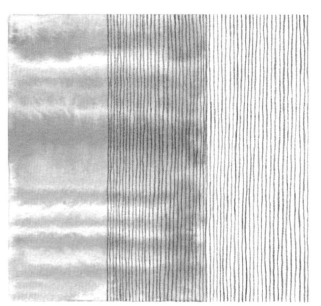

NAPLES YELLOW & ROSE DORÉ
PENCIL & ROUND, 3 & 0

TECHNIQUE

Next, we'll practice the paint on paint layering technique using our purple and blue pigments. Paint a portion of the swatch in the style of your choice (I used wet on dry here) and refine the art. Allow this paint to fully dry and set. Paint the second portion of this swatch in the same way, overlapping the two sections. Refine your edges and allow the piece to dry to complete the test.

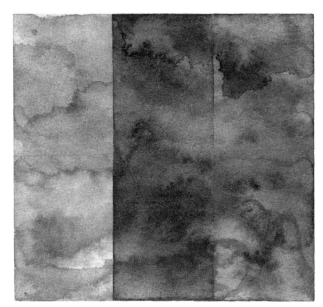

TURQUOISE & DIOXAZINE VIOLET
ROUND. 3

TIP

When layering paint on paint, it can be challenging to keep the bottom layer of art intact. Wait at least a day for the pigment to "set" before applying more paint on top of your design. The longer you allow the paint to rest, the more likely it is that the pigment will stay in place.

TECHNIQUE

This time, try using the wet on wet approach to create more translucent layers. Paint the first portion of your swatch as you normally would, and allow it to fully dry and set. Move on to the second portion of the swatch, brushing over the first painting, while also filling in the rest of the form. Touch up any rough edges to finalize your art.

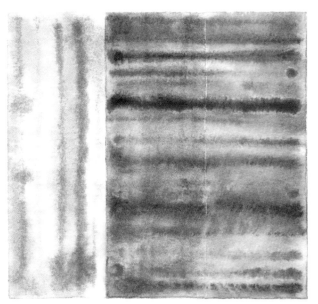

COBALT MAGENTA & PERMANENT MAGENTA
MANGANESE BLUE & ULTRAMARINE . ROUND. 3 & 0

RAW SIENNA & DAVY'S GRAY
ROUND , 3 & SQUARE , 4

TECHNIQUE

Now, let's paint using our black and brown pigments, incorporating the layering technique known as dry brushing. Paint a portion of your swatch, refine the art, and allow it to fully dry. For this swatch I used the wet on dry technique. Next, take a brush loaded with pigment and as little water as possible, and pull it across the surface, filling in part of the painted area and the rest of the swatch. Touch up any problem spots to complete the test.

TIP

Different brushes will make different marks on your page, something you can observe particularly well with the dry brush technique. There are also many ways you can maneuver each brush. For example, the upper swatch's texture is made from a square brush. When working with this brush, I chose to use the larger, flat sides, stroking the bristles across the page. This created a streaky, yet consistent texture. In contrast, the lower swatches texture was developed by stippling the top of a round brush onto the paper's surface. This created a spotty, irregular design.

BURNT UMBER & BURNT SIENNA & IVORY BLACK
ROUND , 3 , 2 & 0

TECHNIQUE

Let's also create some swatch tests where we use dry brushing in a stippling motion. Instead of pulling your brush across the paper, you'll use the tip to dot on the texture. When you're ready, go back in to the painting with a brush loaded with pigment and as little water as possible. Stipple your brush across part of the painted surface while also filling in the rest of the form. Allow this texture to dry and touch up any spots to finalize the art

CHINESE WHITE , ULTRAMARINE VIOLET & ULTRAMARINE
SYNTHETIC SPONGE & ROUND , 3

TECHNIQUE

Now we'll paint with our white and neutral tint pigments. For this final set of swatches, we'll work with stamping using sponges. I've used a synthetic sponge for this top swatch. Paint a portion of your shape using your preferred technique. Next, dampen your sponge with clean water and paint watercolor directly onto the surface. Test the stamp on a scrap page before applying it to your swatch. Refine your art to complete the test.

TIP

When stamping with sponges, consider cutting them into shapes that better work with your design. In this case, I cut the sponges into rectangles and squares to fit the swatch tests more precisely.

NEUTRAL TINT , OPERA ROSE & CADMIUM RED
NATURAL SPONGE & ROUND , 3

TECHNIQUE

This time we'll try natural sponges. Start by painting a section of your swatch and then allow this to dry. Dampen your sponge with water and paint pigments onto its surface. Test this stamp on scrap paper. Once you are happy with the result, press the design onto the swatch, filling in the rest of the form. Allow this art to dry, finishing the design.

MERGING SKILLS & IDEAS

Now that you have explored various layering approaches,
let's use them in compositions to further grow our skills.
We will combine ink and watercolor in a produce study, use
graphite and watercolor in a geometric study, then explore
layering paint on paint to develop a sweet treat design,
as well as a few textural lettering pieces using dry brush
and stamping effects.

A WORK IN PROGRESS

1

SKETCHING AND GUIDES

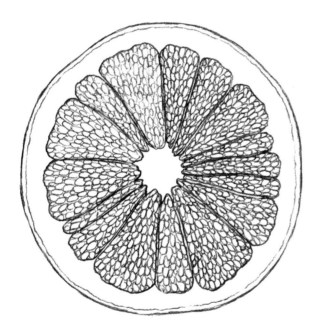

Use my guidelines to start, and plan out the details on a separate page with a sketch, considering what areas you want to layer. Draw light graphite guidelines to reference once you get into final art.

2

PLANNING YOUR COLOR

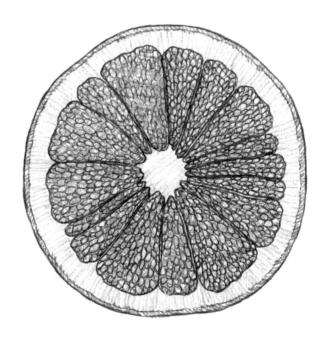

Consider your palette in advance of painting your art. Think about how the colors of one layer can compliment and/or contrast the tones of another. For this piece, I used a darker pink ink on top of a lighter pink watercolor base.

3

APPLYING THE PAINT

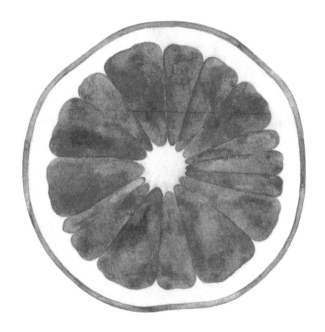

Paint your art using the technique of your choice—
for this composition I chose a wet on dry approach,
incorporating some blooms into the design. Refine
the art and allow it to fully dry before adding your
layers, in this case, the pen and ink.

4

ADDING YOUR LAYERS

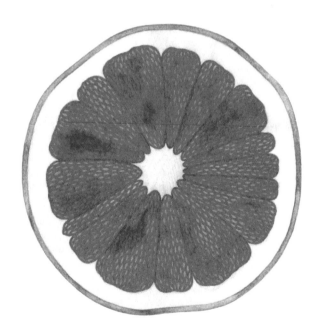

Now that the base layer of the painting is dry,
it's time to add your design on top of it. Here I've
gone in and added details and texture to the fruit.
Refine the drawing and complete your art by
gently erasing any visible graphite guidelines.

TECHNIQUE

First you'll paint your own citrus composition using the pen and ink layering technique. Plan out the specifics of your design with light guidelines and consider your color scheme Paint the study as you normally would. Refine the art, touch up any problem spots and allow it to fully dry. Next, go over the painting with your pen, drawing in the details to complete your design. Refine your drawing. Erase any visible guidelines to complete the study.

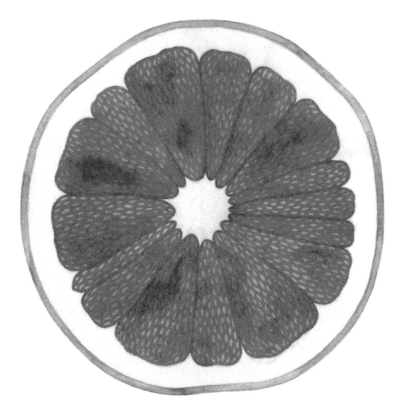

ROSE DORÉ , ALIZARIN CRIMSON , RAW SIENNA & DAVY'S GRAY
PEN & ROUND , O & 3

TIP

Pen and ink act differently when applied to a painted surface versus plain paper. Pen on top of dry watercolor bleeds less than on plain paper, making thinner marks. Consider this while developing your design and also think about your pen choice and color selection. How thick do you want the marks to be? Do you want the ink color to blend into the paint or stand out?

TECHNIQUE

Next, let's paint an arrangement of decorative geometric shapes, and incorporate graphite to add delicate detail to your design. Plan out your study with light guidelines. Paint each of the shapes and refine any problem spots. Since the shapes are small, I used wet on dry for the most control. Allow the pigment to fully dry and erase any graphite lines that you don't want in the final art. Go back in with pencil and fill in the final drawn details to complete your work.

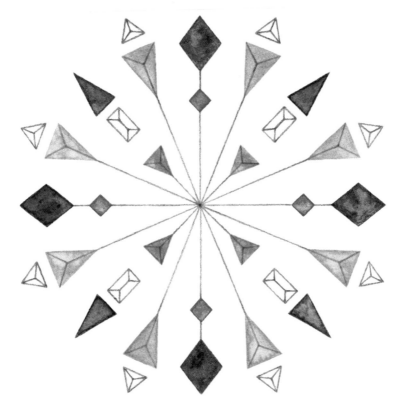

PERMANENT MAGENTA, MAGENTA COBALT,
ULTRAMARINE VIOLET, COBALT BLUE & MANGANESE BLUE
PENCIL & ROUND 0

TIP

Paint first and draw your graphite design second. This allows everything within your composition to line up more precisely. You can easily correct graphite lines that don't hit the right spot by erasing and redrawing them, in comparison to more permanent areas of watercolor paint.

TECHNIQUE

Now, let's move on to a doughnut study, incorporating the paint on paint layering technique. Draw your dessert using light graphite guidelines. Using the wet on wet application approach, paint the full doughnut. Allow this pigment to dry and set overnight. Next, paint the icing layer. Again, allow the pigment to dry and set over night. Finally, paint the toppings layer. Allow the last of the paint to fully dry. Finalize your art by gently erasing any visible guidelines with a kneaded eraser.

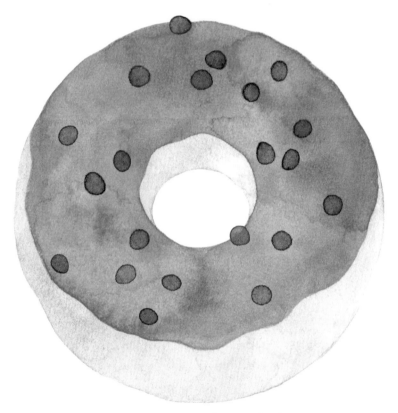

RAW SIENNA & DAVY'S GRAY (TAN)
WINSOR ORANGE & OPERA ROSE (PINK/ORANGE)
BURNT UMBER & BURNT SIENNA (BROWN)
ROUND 0 & 3

TIP

When layering paint on paint multiple times, as shown in this study, you should consider each color in the design carefully. The final layers of pigment can become too dark or muddied if the tones underneath are not complimentary to each other and applied with a light hand.

DAVY'S GRAY & RAW SIENNA

ROUND . 3 & SQUARE , 4

TECHNIQUE

In this composition we'll explore lettering using the dry brush layering technique. I'm focusing on a single letter "H" for this study. Sketch out your design with light guidelines and consider what colors will enhance your composition. Paint the first layer using the wet on dry approach. For me, the first layer was the gray portion of the design. Allow this art to fully dry, set for a day, and go back in with a brush loaded with pigment and as little water as possible. Pulling it across the paper's surface, fill in the next layer with the dry brush technique. Allow the design to full dry and touch up any problem spots. Erase any visible guidelines to complete this type study.

TIP

Some brushes have stiffer bristles than others. These different bristles will creat different effects when dry brushing. Using brushe with stiff bristles creates more defined textures and softer bristles create more subtle textures.

TECHNIQUE

Finally, let's paint a more organic, textured lettering study using the stamping technique. Plan your design with subtle guidelines and consider your color palette. Start by painting the type layer first—I chose a dotted wet on wet approach to enhance the stamping texture. Allow this paint to fully dry. Wet your stamp slightly, in this case a sponge, and paint watercolors onto the surface. Test your stamp on scrap paper. Once you are happy with the design, apply the sponge to your study, completing the composition. Allow this pigment to fully dry. Touch up any rough spots and erase visible guidelines to complete your art.

VIVID GREEN, CADMIUM YELLOW & TURQUOISE
NATURAL SPONGE & ROUND 0 & 3

TIP

To get the most detail from stamping tools, you don't want to over saturate them with water. This will cause their design to blur on the page. Test your stamps on a separate piece of paper to find the right balance of pigment to water before committing to using them on a design.

FREEFORM

EXPERIMENTS

GOING ON TO DEVELOP FURTHER EXPLORATIONS

Now that you've learned the fundamentals of watercolor painting, along with some more specialized techniques, it's time to explore freely and develop your personal style. Put your own spin on this medium through the techniques you choose, how you combine them, and how they're merged with compositions. This is a moment to go with your gut and figure out what you like best! These last ten experiments provide you with blank pages to play and paint on, along with some of my tips on creating compositions.

1

WORK WITH THE SKILLS YOU ENJOY

In the remaining pages, play with the techniques that you most enjoyed working with in this book. These are the techniques that will become the base of your personal aesthetic. Much of my work is a combination of wet on dry and wet on wet painting. I also enjoy working with mixed media and layering paint on paint. You don't need to use every watercolor skill to be a watercolor artist—focusing on the ones you love will only make your work stronger.

2

COMBINE STYLES THAT SPEAK TO YOU

There are an infinite numbers of ways to combine these techniques together. Play with different combinations and see which work best for you. How you merge these skills will add another level of personalization to your art. I like to paint clean, detailed pieces using wet on wet and wet on dry to create intricate internal textures that embrace blooms and organic arrangements of ombré color. These choices help to make the work uniquely my own.

3

EXPLORE YOUR FAVORITE INSPIRATION

Think about your favorite foods, objects you love, places that are special, etc. These are the ideas that inspire you to paint again and again. Merging your favorite techniques with things that inspire you will bring this whole process together. I enjoy exploring organic, natural, and scientific compositions. I also love to work with handlettering and patterns. Experiment with the ideas that you love.

4

FIND YOUR PERSONAL STYLE

A single blank page can be intimidating to work with. Before you start this freeform section, consider sketching a design. Once you've got a plan, you can break the composition down into steps. As you complete each of the compositions, reflect on how they are defining your personal style, allowing your work to evolve as you go.

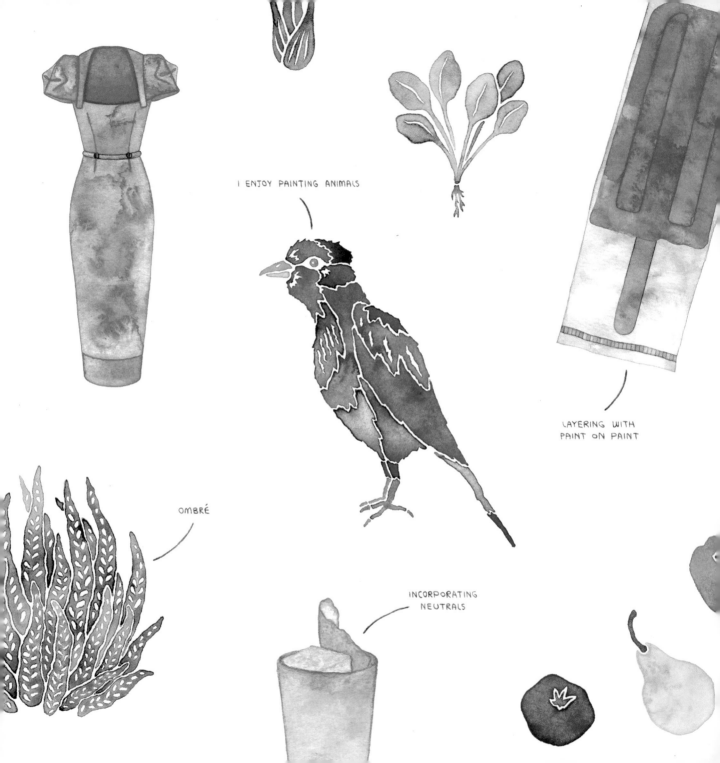

I ENJOY PAINTING ANIMALS

LAYERING WITH
PAINT ON PAINT

OMBRÉ

INCORPORATING
NEUTRALS

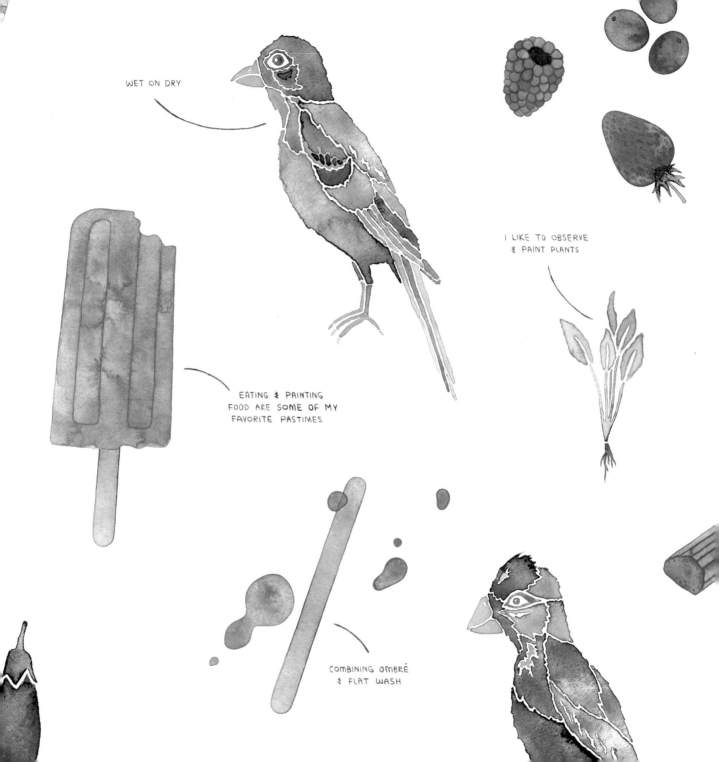

WET ON DRY

I LIKE TO OBSERVE
& PAINT PLANTS

EATING & PAINTING
FOOD ARE SOME OF MY
FAVORITE PASTIMES

COMBINING OMBRÉ
& FLAT WASH

TIP
Start with sketches on
a separate sheet of paper.
This way, there is less
pressure to get your design
just right the first time.

TIP
Pick your favorite technique
first and think of concepts
that best highlight its
aesthetic. Work from there
to develop a composition
that captures these ideas.

TIP

Think of something you love—maybe a favorite food or plant or animal. Sketch a composition around these elements and think about which techniques make sense to use. Turn that concept into a painting.

TIP
Select two or three
techniques you have
enjoyed experimenting with.
Sketch out several concepts
that combine these skills
into a single composition.
Paint your favorite of
these different directions.

TIP

Do some visual research to inspire you. Go to a museum or a park. Take some time to observe and sketch. Bring these new ideas back, and use them as a jumping off point for your next painting.

TIP

My preference is for round
brushes because they allow
for the most control over
small spaces, but they also
enable you to fill in larger
spaces. Try different paint
brush shapes and sizes
to see what you prefer.

TIP
Magenta and orange is
one of my favorite color
combinations to paint in
watercolor. Explore different
pigment mixes to find the
color combos that you love.

TIP

I like to move slowly
through a painting, so as
not to accidentally smudge
a wet area of paint with
my hand. I would suggest
painting objects in two
or three different areas of
your composition, letting
them dry, and then painting
two or three more.

TIP

Keep in mind that you can reuse dried mixes of watercolor off your palette again and again. Don't clean your paints unless they are a complete muddy mess, because until then they are still in perfect shape for your next piece of art.

TIP

Small experiments can
lead to big projects. Don't
disregard any of your work.
Even if it feels imperfect
to you right now it may
inspire future ideas.